Out of the cradle endlessly rocking,
Out of the mockingbird's throat, the musical
 shuttle...
A reminiscence sing.

Walt Whitman

It's a poor sort of memory that only works backwards.

Lewis Carroll

BRIEF ENCOUNTERS
Meetings with Remarkable People

BILL LONG

New Island Books
Dublin

BRIEF ENCOUNTERS
First published June 1999 by
New Island Books
2 Brookside
Dundrum Road
Dublin 14
Ireland

ISBN 1 874597 84 7

**New Island Books receives financial assistance from The Arts Council
(An Chomhairle Ealaíon), Dublin, Ireland.**

Cover design: Slick Fish Design
Cover photograph: Harry Long
Typesetting: New Island Books
Printed in Ireland by Colour Books Ltd.

Contents

Dedicated to
Noel and Phyllis Browne
who, in their lives were inseparable,
and in his death were not divided.

Introduction

In over half-a-hundred years of knocking round—and being knocked around by—this tortured old planet, I've encountered just a few men and women of the same temper as myself; people with whom I had instant rapport; and contradictorily, found some kind of common-denominator in our seemingly incompatible idiosyncrasies, eccentricities and foibles. For the most part we met only once or twice, and then no more. Just one of the many protagonists in this book has continued to be a 'presence' in my life over many years. That is my *doppelgänger* and he has come and gone as he pleases; I have seen more of him than of the others. Still, he does qualify for inclusion, if only in this Introduction, for my encounters with him are always 'brief'.

He often departs as quickly as he materialises, invariably in high dudgeon at my inability to accept his well-meant criticism with anything even approaching good-grace. I am sure he has, on many occasions, abandoned all hope of ever jolting me out of my irritating intransigence, only to return, unexpectedly, ever hopeful, to try again. However there were many occasions in many places where my long-suffering *doppelgänger* must have been pleased with me. Pleased that my initiative and my audacity ensured that, with his prompting, many a brief encounter proved possible.

These moments with all of the protagonists have been
unique, truly empathic experiences, and the value of the legacy
they've left me incalculable. They were such high-points that
continued meetings, even if possible, were neither necessary
nor desirable; for after such high-points, all subsequent
meetings ran the risk of being lesser moments, perhaps even
disappointments. Nothing would have been gained by meeting
regularly, by engaging in small-talk over cups of tea or coffee.

And, occasionally, there were these extraordinary connec-
tions between the protagonists; connections of which I was not
at all aware at the time of meeting. Associations which yielded
themselves up only after a lapse of years, like some
miraculous, retrospective X-ray picture revealing the subtle
secrets under the skin; the arteries and the tributary veins, the
bones and the sinews, all that constitutes the tell-tale map of
our complex and subtle human physiognomy.

So, it was usually hail and farewell, with sometimes,
between the hail and the farewell a common ground, what
Rupert Brooke described as 'This resting place, made fair by
one another for a while ...'

And it is of those resting places, those shared moments, that
I write. Moments achieved, sometimes by my own temerity,
sometimes by ostensibly fortuitous chance. I say ostensibly,
because for me chance does not really exist in life. I think
everything in life follow rules, patterns. Life is too serious and
important to be left to chance. Life has great significance and is
ordered by some force outside ourselves; some mysterious and
benign force. Life is a sacred and a holy thing, all mystery and
miracle.

All those brief encounters then, were just part of that mystery, part of that miracle. The various protagonists, and myself, just ships passing, courteously lowering flags in mutual salute, acknowledging each other briefly, before passing on and dipping forever over the horizons of our separate lives.

And my *doppelgänger?* Well, he is special, he is many things; not least the voice of conscience. The voice of conscience that, among many other things, is constantly reminding me that for as long as I live in suburbia, I live in exile. He it was, my earnest, well-meaning, ever-solicitous *doppelgänger,* who, more years ago than I care to remember, warned me against the insidiousness of suburban living. And he it has been who, ever since, regularly returns to remind me of my folly in not heeding him.

He is odd, idiosyncratic, eccentric, demanding and arrogant. Yet, I can do nothing to deter him from importuning me, whenever he so wishes. On the one hand I owe him nothing; on the other hand I owe him everything. I love him, hate him; am in turn besotted by him or impervious to his blandishments. As well try to lose him as lose my shadow. He is my hope and my despair, my light and my darkness. He is my *doppelgänger!* He must be the chosen one, with whom I pray the brief encounters will continue, until ultimately, one way or another, I leave this place of exile and go home.

Old Yellow Gloves

Raymond Chandler

In the summer of 1958 I worked in London and rented a small *pied à terre* at Swan Walk, in Chelsea. I had for near-neighbour at Number 8, two doors away, an elderly, distinguished gentleman who always wore yellow gloves.

Now, I must admit, that my initial perception of my neighbour was not that he was a writer; far from it. Indeed, from the start, 'Old Yellow Gloves', as I always thought of him—and still do—struck me as a man who may have had a colourful, if not downright shady, past.

He was of medium height, bordering on the frail. His clothes were tasteful and expensive; his one foible in this respect being the finely crocheted yellow gloves worn with all of his many outfits. The silver hair, the horn-rimmed glasses, the pipe, added that final *distingué* touch. Perhaps, I thought after first seeing him, he was a retired gangland boss, or big-time gambler, come, in the evening of his life, to the relative peace and anonymity of Chelsea. And this perception was endorsed for me by the ever-present, deferential 'minder', and the chauffeur-driven limousine that came, twice a week, to take them away. They always returned late in the afternoon, the car-boot filled with shopping bags from the better London department stores.

And every week there would be a party at Number 8; invariably formal affairs, the guests arriving by taxi and limousine; mostly young women, fashionably dressed in very expensive décolletage. Occasionally there would be an older woman, or an older man, but mostly they were young, classy, vivacious females, whose polite laughter filled the Chelsea evening as they moved from the kerbside to the halldoor, where, invariably, Old Yellow Gloves, resplendent in tuxedo and red bow-tie, waited to welcome them.

London, at any time, but especially in that summer of '58, was certainly a good place in which to seek anonymity, if that, as I had initially thought, was what Old Yellow Gloves was seeking. The whole area round South Kensington and Chelsea was swinging. There was an infectious buzz in the air. Sophisticated boutiques, art galleries, curio shops, junk shops, restaurants, bistros, coffee-shops, mock-country pubs, little chintzy tea-rooms, were being opened in every street, mews and alley.

There was an air of perpetual carnival, as if some colourful, madcap circus had come to town and refused to leave. All the beautiful young—and sometimes, not so young—people in the world seemed to have discovered London, and were gravitating to South Ken and the King's Road. Fittingly, the Everley Brothers were top of the pop charts with 'All I Have to Do Is Dream'. It was not possible to walk anywhere in that whole area without hearing the song blaring from the record stores and the madly pulsating juke-boxes in the pubs and coffee-shops.

While I was still speculating as to the real identity of Old Yellow Gloves, fate, or chance, or good fortune—call it what

you will, according to your personal beliefs or disbeliefs—
stepped in. One damp, overcast morning, while I waited at the
corner stop for a bus to Oxford Street, the chauffeur-driven
limousine drew up at the kerb. The deferential 'minder' was
instructed to ask me if I would like a lift. He invited me to sit
between the old man and himself on the capacious back-seat.

Old Yellow Gloves extended a gloved hand and introduced
himself as Raymond Chandler, and the 'minder' as his nurse.
Nonplussed, I began to tell him my name and thank him for the
lift, but got no further than the first few words, when he caught
my arm, smiled, and interrupted: 'Excuse me, excuse me! That
accent! Let me guess where in Ireland you come from. Pride
myself on my ear for speech, for accents. Let me see, now.
Somewhere in the South-East? Maybe Wexford? But no, no.
Waterford! That's it, Waterford!'

On hearing that I did come from Waterford, Chandler was
quite visibly moved, and as we crawled along in the heavy
morning traffic, he told me that his mother had come from that
city. She was, he said, a Thornton, of the old-established legal
family. 'The Thorntons of Cathedral Square,' he grinned, with
the shadow of a cynical smile and the slightest edge of
mockery in his tone. 'I. Thornton and Son, Solicitors and
Notaries Public!' he declaimed with mock pomposity.

Then he turned his face away, out across the barely moving
sea of Knightsbridge traffic, and when he looked at me again,
he had lost the cynical look, the mocking smile. Behind the
thick lens of his glasses his eyes were soft now with memories.
And he had started memories for me too. Memories of the
Waterford in which I had grown up; memories of the big, gaunt
Thornton offices in Cathedral Square, with the great shining

brass door-knocker and the brass name-plate to match, and the black-and-gold legal lettering on the windows. And on one side of the square, soot-begrimed trees, pigeon-infested, the pavement and railings mottled with their droppings, the unseen chortling birds a constant threat to passers-by.

The old writer sighed then, coming back from a long way off, and said, 'Ah, Waterford! I remember Waterford well, from going there summers when I was just a kid. Uncle Ernest—my mother's brother that is— was head of the family then, and of the legal practice. Ruled both with an iron hand in an iron glove! A regular old tyrant was Uncle Ernie! Upper middle-class Protestants, the Thorntons, and godawful snobs! Still I always had a good time in Waterford!'

Just then we reached the top of Grosvenor Square, where I had asked to be dropped. As I got out, Chandler shook my hand and said, 'Say, why don't you come to one of my parties? My next one, Godammit! Love to have you. Let you know when.' And then he was gone, swallowed up in the great moving maw of the London traffic. I stood in the drizzling rain and watched the black limousine go down the side of the Square, past the entrance to Brook Street, where my office was, and on to Claridges, where Chandler had said he was having breakfast with Stephen Spender and his wife, Natasha.

The thing that struck me most forcibly at that first, brief meeting was his accent; an amalgam, I was to discover from subsequent meetings, reflecting the diverse influences to which he had been exposed from an early age. The combined influences of his Irish boyhood summers spent in Waterford with the Thorntons, his English schooling at Dulwich College, and the long years in America, had given him an extraordinary

manner of speech. His accent was, while tinged with a slight American drawl, very English, or rather Anglo-Irish; while his way of actually phrasing things owed much to the American vernacular. As if Al Capone, retaining his colourful American idiom, was doing his best to acquire an Oxford accent.

Overjoyed at my meeting with Chandler, I tried to put out of my mind any possibility of being ever invited to one of his parties. I thought of it in the same way one thinks of promises, made in good faith, to keep in touch with people met in hospital or on holiday. While the intention is always good, it somehow inevitably loses the name of action. Then, just a week after our meeting, I returned home one evening to find a note in my letter box— 'Party Saturday at eight. Please dress. Look forward to seeing you. Ray.'

For the remainder of that Chelsea summer I was invited to every one of Ray Chandler's weekly parties. Some of the guests were regulars, others came once and were seen no more. I was always introduced by Ray as his 'fellow Waterfordian', and he never tired of telling people of how chuffed he was to have someone from 'the old city' as close neighbour and friend. The Spenders, Stephen and Natasha, were regulars, and were, together with some other good friends, largely responsible for the weekly guest list; ensuring that most of the guests were attractive, intelligent, vivacious young women, who would help lift the flagging spirits of the old writer. The other guests were, for the most part, people who had known the Chandlers on their frequent visits to London, when Ray's wife, Chrissie, was still alive. Often, when some new guest complimented him on the magnificence of the evening, Old Yellow Gloves would smile a little sadly and say, 'Gee, thanks! You think this was a party? Should've seen the parties

Chrissie and I threw in this town! Ah, well, everything passes.
But we do our best, we do our best.'

And he did do his best at those wonderful evenings. He did
his best to be a good host, because he was, despite all his
idiosyncrasies and foibles, an innately kind, gracious and
generous man. But he was seventy then, a widower and in very
poor health. He tired easily, especially when trying to cope
with groups of people. So, often, when he had done his duty,
when the guests were all introduced and the party swinging, he
would take a bottle of Russian vodka, a siphon of soda and
three glasses—one full of ice cubes—and he and I would slip
away to his study. There he would drink two, sometimes three
vodkas to my one, and talk about Waterford and his mother's
family, the Thorntons of Cathedral Square.

Now, in all these sessions, I was not just there as a good
listener. Ray liked me to talk to him; tell him about the
Waterford in which I had grown up, forty years after he had
known it. He would often take pencil and paper, and make lists
of streets and squares and laneways of the old city, confirming
with me that his memory of them was accurate. He loved to
talk about the Port and of the ships that traded in and out of it;
making lists of the ships he remembered lying-up in the river at
the turn of the century. Then he would ask me to list the names
of the ships I remembered from the Forties and Fifties. Alas,
while the names of the streets, and squares, and laneways had
not changed, the names of the ships had. He also loved to
reminisce about some of the upper-class families, the
Dawnays, the Grubbs, the Carews, the Congreves, mostly
Protestant, like the Thorntons, at whose homes, as a child, he
had played tennis and croquet. It always surprised him to hear
that so many of them had survived into my time. 'Thought, at

the turn of the century, they were a dying breed, and couldn't possibly survive another generation,' he would say, mischievously.

The Waterford connection was of immense importance to Chandler. He had first gone there with his mother, after his father, an American, had deserted them when Ray was only seven. The Thornton family, to their credit, had rallied round, and arranged for Florence and her son to leave America. After a short period in Waterford they had settled in London with his grandmother and aunt. For many summers, during his pre-teen and teenage years, Chandler and his mother spent their vacations in Waterford. From those long-ago times he remembered clearly that, 'Not just Uncle Ernest, but the whole family, were godawful snobs! Full of bloody righteousness. Tension in the house all the time. And every goddam thing had to be Protestant! The maids, the cook, even the men who worked in the garden.'

It was very obvious that his childhood experiences in Waterford had made an indelible impression on Ray Chandler. Those summers spent with the Thorntons afforded him a great appreciation of the social distinctions obtaining in a society that was neither urban, nor rural, but 'county'. He admitted to me that, as a boy, he had been so inculcated in this particular Protestant 'county' culture, that it had remained part of him for the rest of his life. The snobbery of the Thorntons had, he said, rubbed off on him and made him, too, a snob for life. For instance, he told me, late one party-night, after several vodkas in the back study, that he hated to be called, as he often was, 'Irish American', because, in his estimation, that usually meant 'Catholic and working-class'.

Once, when he had taken more vodka than usual, he felt he should make some apologia for his inability to shake-off this influence and change his attitude. 'The Thorntons,' he said sadly, 'saw to it that I grew up with a ferocious contempt for Catholics, and unfortunately, to this day, I have a problem with that.' Whenever we talked Irish history, as we often did, he always maintained that—'the only Irish patriots with any brains came from the professional classes'. And for Ray, the professional classes in Southern Ireland were always Protestant.

One particular evening, when he thought he had gone too far in his ridiculing of Catholics, he paid them the back-handed compliment of saying that, to their credit, the Catholic majority never engaged in any real persecution of the Protestant minority. But during all our talks that summer, I got the definite feeling from Ray Chandler that the issue, the real issue, for the Thorntons and for him, was not religion, but class and education. He remained—and freely admitted this—incorrigibly class-conscious all of his life, and constantly extolled the advantages of a good, formal education.

I remember, late one night, discussing this with him. I told him that he struck me as being the opposite of Ernest Hemingway, who felt that where people came from didn't matter, but where they were going did. Now, I didn't particularly mean this as a compliment, but he mistook it for one and thanked me. 'Very perceptive of you. You're absolutely right, you know. With me, where they come from is the important thing.'

And it was, as I discovered some time later, when a regular guest, a well-known and respected journalist, not knowing

Ray's strong feelings about formal education, boasted that he had left school at the age of fourteen; working as a printer's devil in a newspaper office, to help support his impoverished family. Ray was shocked, and greatly affronted; his reaction was brutally uncompromising. The unfortunate journalist never appeared at his parties again. Chandler's only comment to me was, to say the least, ambiguous and smacked of double-think. 'I wish,' he said, 'the fellow had kept that information to himself. I did rather like him, really. But now that I *know*, it's different!'

My meetings with Ray Chandler that summer were not all at his weekly parties. We sometimes walked together in the Botanical Gardens in Chelsea, close to where we lived. He loved the huge conservatories, with their exotic plants and shrubs. They reminded him of the 'Big Houses' in Co Waterford, which he had visited with his Uncle Ernest and his mother, Florence. The owners of the Big Houses, being mostly Protestant, had their legal business handled by Uncle Ernest's law firm, and the Thorntons were always welcome visitors.

On one occasion, he remembered with particular pleasure Mount Congreve, a country estate, five miles from Waterford city; describing to me how the woods ran right down to the water's edge at a wide bend of the river Suir. He really rhapsodised about the place, telling how he and his mother would steal away during afternoon tea, leaving his uncle holding forth with the client about politics or law, and go out to the great walled-garden. There they would sit, sometimes in the sun, sometimes in the potting-shed with the head gardener (or bothy-man as he was called), or walk with him in the endless maze of flowers and vegetables. And because the old gardener

liked Florence, they would always leave with an enormous bunch of freshly cut flowers.

'That garden!' Ray said. 'I can still remember, from nearly sixty years ago, the lovely, heady scent of the flowers which would permeate Uncle Ernest's car for days afterwards. And the rich smell of all the ripening fruit. But strangely, the smell I remember best is the smell of the tobacco the old bothy-man smoked in his enormous, bent-shank pipe. I remember resolving when I was ten or eleven, after those visits to Mount Congreve, to smoke a pipe when I grew up. And by God, I did, and still do!'

I waited to make sure he had finished. We walked on slowly. Then, as casually as possible, I said, 'Tell me, Ray, what was that old gardener's name?'

Chandler looked disconcerted for a moment, puffed his pipe, and then, with a smug, mischievous smile answered, 'Savage. Mister Savage! That was his name. Never knew his first name,' he paused, then added, with a touch of sarcasm, 'He was Protestant, of course! But all that was sixty years ago. Say, did you ever go to Mount Congreve?'

'Yes. Often. I knew the old gardener's son very well. Same name as his father. George. Followed his father as head gardener. You see, we lived for many years, just downstream from Mount Congreve.'

At this Old Yellow Gloves smiled knowingly, and nodded his head. He said nothing, but I sensed that, even though I was not a Protestant, my erstwhile friendship with George Savage, Junior, pleased him. I felt accepted, by association, in a way in which I had not been prior to that.

It was such small, shared memories as this that gave Ray Chandler and myself a common ground. He never tired of returning along the iron chains of memory, that bound him like some invisible umbilical cord, to those well-remembered boyhood summers in Waterford. For instance, one evening he began to speak of the network of narrow streets at the centre of the old city, and mentioned a second-hand book shop to which he had often gone with his Uncle Ernest. Owned by a family called Power, it was familiarly and affectionately known as 'Stickyback's'; there being as many Powers in Waterford as sand on the seashore. But neither he nor I could recall why 'Stickyback's'.

It was the same book shop in which, nearly forty years later, I had bought my first Chandler books; second-hand paper-back editions of *Farewell, My Lovely* and *The High Window,* and made the acquaintance of the nonpareil Philip Marlowe, one of the first real detective heroes. When I told him this he became quite emotional, saying nothing other than repeating how much the old city meant to him.

'You know,' he said, the eyes gone soft behind the thick lenses again, 'of all the places—and I mean all the places— I've lived in, Waterford is the place that, in the mind, draws me back all the time.'

Days later, at one of the soirées, he surprised me by mentioning the bookshop again. Not so much by mentioning it, but by the context in which it was mentioned. He explained that he had been thinking about that old bookshop, about the maze of narrow streets in which it was located, and had thought how wonderful it would be to use it as a setting for a new Philip Marlowe book. And before I could react or

comment, he was off into the detail ... Marlowe on vacation in Ireland ... stops over for a few days in Waterford ... finds an old pub he likes on the quays ... drinking there, witnesses a brawl between sailors from different ships ... next day hears one of them has been murdered ... his body dumped in the doorway of the book shop ... that night, drinking in the same pub, Marlowe, recognised by the American skipper of the victim's ship, agrees to do a little investigative work ... this leads him into the 'low' life of the city ... he discovers a vicious prostitution racket

At this point, Chandler stopped suddenly, looked at me with a sardonic smile and asked, 'Say, Bill, would you think there was much prostitution in Waterford Port in those days?'

But before I could begin to answer, he was pouring another vodka and had changed the subject, as if it didn't interest him any longer. Just as well, for his health was such now that his work-rate was very low, his writing output minimal. In the whole of that year—1958—he had only written a review of an Ian Fleming novel for *The Sunday Times*, and a Preface to Frank Norman's book, *Bang To Rights*. He had started to write a play but got nowhere with it. A cookbook he had planned to collaborate on with his friend Helga Green, *The Cook Book For Idiots,* also foundered. He was very obviously drifting sadly toward the edge.

At this time, when the centre had failed to hold, and Ray was visibly beginning to disintegrate, we discovered a little tea shop on the King's Road, where he could have his freshly cooked flapjacks drenched in real maple syrup. Often at week-ends, we would stroll round there and sit for two hours or more under the awning. One afternoon, when he was particularly

low in spirit, he mentioned, for the first and last time, Dulwich College, to which he had gone, as a boy of twelve, in 1900. He was very voluble about the place, remembering it with great affection; especially for the education he had received there in Classics. He mentioned the great influence the Head, A.H. Gilkes, had had on him. 'Gilkes,' Ray said, 'was big on Cicero. Told us boys that Cicero had a large plant of conceit growing in his heart, and the wise old man watered it every day!'

Dulwich and Gilkes had taught him a lot ... 'All that good old Public School Code stuff, that stays with you forever. Taught us that real manliness was forgetfulness of self. A man of honour, Gilkes used to say, was always capable of understanding what was good, ready always to subordinate the poorer part of his nature to the higher part.'

This line of reminiscence and philosophising took him into what he called one of his 'little reveries'. For several minutes his thoughts were far away, his eyes moist, and when he came back from that great distance and focused on the tea shop again, his voice was soft ... 'That Code moulded my character, I suppose. Afterwards, years and years later, in America, I kind of transplanted a lot of it into Philip Marlowe. Helps explain some of his behaviour, I guess.'

That was our last visit to the tea shop. Before I left him that afternoon he was busy making plans to take me to Dulwich, to see what was left of the old College, as he remembered it. Some of that neighbourhood, he explained, had been destroyed by German bombs during the Blitz; including Whitfield Lodge, at Alleyn Park, near the school, where he and his mother had lived with his grandmother and aunt. We never went. Like

many of the plans Ray made in those final days of that Chelsea summer, nothing came of it.

One evening, around Mid-Summer Day, he took me to dinner at Claridges, one of his favourite London restaurants. He was in good spirits, talkative, witty, full of wise-cracks, as if, for a few borrowed hours, he had become his own creation—Philip Marlowe. I was leaving for a stint in Rome the following day, and he was planning to return to America in August. It was most unlikely that we should meet again. He was in such fine form, in command of things, that I left the ordering to him. We both had Chicken Kiev for our main course. But by the time we had sipped our aperitifs and got through our starters, he had begun to tire considerably. When the main course arrived his brio was gone, his mood changed, as it so often did, to one of near depression. Whatever appetite he had was gone now. He took his fork and played with the beautifully presented chicken on his plate, turning it over, tentatively, as if it were untouchable. Then, with a little sigh of resignation, he pushed his plate away from him and called the *maître d'*. His voice was soft, polite, but very firm.

'Andre!'

'Yes, Monsieur Chandler. What can I do for you?'

'You can remove this chicken, Andre, please.'

'Oh, it is not to Monsieur's liking?'

'Don't know, Andre. Haven't tasted it. Don't need to, really. Looks as if it must have been dead awhile before they killed it. Suggest you take it away and give the poor thing a decent burial.'

Andre, well-used to Ray's moods and eccentricities, smiled as he took the plate away, with a polite ... 'Ah, Monsieur will have his little jokes!'

Ray's quip about the dead chicken was one worthy of his most famous creation, Philip Marlowe. I am certain there was nothing wrong with the chicken; mine was perfect. But by then I knew him well enough to appreciate his foibles. I never saw him again after that evening. The following spring—March 27th, 1959 to be exact—I heard the news on early morning radio in my Rome hotel ... 'Raymond Chandler, the writer, died yesterday at his residence in La Jolla ...' It would have pleased him greatly that they did not refer to him as Irish-American.

I walked in the Via Veneto after breakfast, impervious to the sound of the traffic, and the raucous shouts of the kamikaze Italian drivers as they jockeyed for pole position at the traffic lights. I was thinking of something Ray Chandler had said to me one evening as we walked in the King's Road, Chelsea. He was depressed, sad at having passed the point where he might ever write again, anxious to justify his being alive.

'Any man,' he said wearily, but with great conviction, 'who can write a page of living prose adds something to our life, illuminates the dark a bit for others. And I could do that, I could do that ... once. You know, Bill, an artist can never deny his art. Indeed, he would never want to. Why should he? For, you see, if you believe in an ideal, you don't own it. It owns you!'

In my brief encounter with Old Yellow Gloves he certainly enriched my life, gave me new perspectives on many things. I often think of him, often take down one of his novels, open it at

random and read a few pages, just for the sheer pleasure of the pace, and the economy of the old man's style. And whenever I visit Waterford, I always take a stroll along the quays, and through the narrow side-streets, leading eventually to Cathedral Square. 'Stickyback' Power's old book shop is gone now, but the great, gaunt Thornton house still stands. Going slowly past it I fancy I can hear the stentorian voice of Uncle Ernest, echoing down the arches of the years, with its fine, fierce Protestant righteousness ... 'My God! Florence's boy! Why did he have to write all those awful books?'

The Man Who Knew Zane Grey

Tom 'Mexico' Mullins

In the Munster glen where I was born and grew up, I first met Tom Mullins. It was the summer of 1943, two months before I went away to boarding school for the first time. He was seventy-five then and I was eleven. Tom was a contemporary of my maternal grandfather. They had grown up together, on neighbouring small-holdings. In his mid-twenties Tom had emigrated to America, while my grandfather had remained at home, to get married and work the land.

During my early childhood, from the age of four or five, when I first began to notice such things, I can remember my grandfather receiving sporadic letters from America, from his friend Tom Mullins. The arrival of these letters, often at two- or three-month intervals, was always treated as a very special occasion. You see, very few people from our parish had emigrated to the States, and the few who had were not great letter-writers. Indeed, many of them were not even literate. Not so Tom Mullins; he was, according to my grandfather, well-read, and with a great command of language. So, when Tom's letter arrived, word went out to the far-flung farms across our glen, that Mickey had got the American letter again, and it would be read at the next 'open night' at our house—Kiely's of Kilfarrassy.

There was an open night every week at our house, usually on Friday; but that was a moveable feast, depending on its clashing with a wake or a wedding, or a 'Stations' Mass. Indeed, sometimes if the humour was on my grandfather, there would be two 'open nights' in a week. I can remember well the three or four times a year when the American letter was read; the crowd was always four or five times greater than the group of musicians, storytellers and singers who usually assembled.

A thing I remember about those American letters was the lovely calligraphic hand in which they were written. Through my grandfather's reading of them the listeners were kept informed, over the years, of wandering Tom Mullins's adventures in America. He had started as a furnace-man in Pittsburgh, gravitated from there to a variety of jobs in the Midwest and by the time I was old enough to hear the letters read, had been working for several years as a ranch hand near El Paso, on the Mexican border. From that time on, every letter contained a reference to someone called Zane … Zane Grey, a friend of Tom's, who visited El Paso regularly and wrote stories about 'The West'.

So when Tom Mullins eventually returned to spend the last years of his life in Ireland he had already been nicknamed 'Mexico'. Now 'Mexico', during his nomadic life in 'The States', had certainly gathered no moss, no money or material possessions. Within a week of returning he was working for a local farmer, Bob Roche, and as part of the deal, had accommodation in a loft above the stables. The arrangement was that he do light farm-work only, this leaving him ample time to work around the glen as an itinerant chimney-sweep.

He was a small, lean man, his skin wrinkled and bronzed from his days in the Southwestern sun. He always wore a tattered sombrero, and a brown-and-black striped poncho. I remember well as a boy, being intrigued by the funny, wide-brimmed hat and the shapeless cloak, as I thought of it, and asking my grandfather what they were. 'Mexico' spoke with a real American 'twang' and walked with a pronounced limp. My grandfather explained that the limp was the result of being badly shot during a range war on the Mexican border. On one occasion the old cowboy actually showed us marks on his arms which were, he said, from bullets in a street-fight in Santa Fe. Never did it occur to me then, or subsequently, to doubt the veracity of anything the old man told us.

My first meeting with 'Mexico' was when he came, one July evening, to sweep our chimney. On hearing from my grandfather that I was about to go off to boarding school a few weeks later, he showed a tremendous interest in me. When he had finished his work in the chimney, my grandfather and he and I sat outside and drank large mugs of fresh buttermilk from that day's churning, and watched the sun go down on the Comeragh mountains. He talked a little about life in Texas and Mexico and then, quite arbitrarily, turned to me.

'Say, boy, what you wanna be whin you git through school?'

My hesitation to answer seemed to irritate him. 'Well, c'mon! You gotta know where you're a-goin', young fella. Don't wanna be like me, now, do you? All shot up an' old an' nothin' to show for it.'

'Why, no sir,' I stammered, at the same envying him all his travel and adventures.

'You wanna keep your head down with them books, boy. Git all the larnin' you can. More to life than jest travellin'. That right, Mickey?'

'Wouldn't know, Tom,' my grandfather answered laconically. 'Never travelled further than Waterford myself.'

'Don't really make no differ, anyways,' the old cow-hand said, tipping his floppy old sombrero down over his eyes to shield them from the rays of the setting sun. 'Best travel is all in the mind, an' in books, boy. Don't you forget books!'

A week later I came home from a day of footing turf on the bog to find a small brown paper parcel, loosely tied with twine, addressed simply to ... 'The Boy'. It was from 'Mexico', and contained two books and a short note ... 'One book is for you to keep, to take to college with you. The other is just a lend. When you give it back you can have more.' The book I was invited to keep was a well-read, well-worn copy of *The Imitation of Christ;* the other was *Riders of The Purple Sage.* I had never heard of either. The first, bound in dull, brown board, did not attract me nearly as much as the second—a paperback, with a lurid, graphic cover, depicting a group of cowboys, riding at full gallop across the open range, bent low against the flying manes of their horses, guns blazing, against a backdrop of distant buttes.

Riders of The Purple Sage had been inscribed by the author: 'To my good friend, Tom Mullins ... in gratitude, Zane Grey.' *The Imitation of Christ*, written by someone called Thomas a Kempis, had no such inscription.

'Why didn't Thomas a Kempis write something in his book?' I asked my grandfather in my childish naivety.

'Because,' the old man explained patiently, 'poor old Tom died about four hundred years ago. 'Mexico' never knew *him*.'

'And Zane Grey? Did he know Zane Grey?'

'Sure he did. Remember, he's the one mentioned in some of his letters. 'Mexico' tells me this fella Grey wrote a lot of books.'

'And does 'Mexico' have them all?'

'Most of them, I think.'

'So when I've finished reading this I can have the others?'

'Sure you can. He said so, didn't he?'

I read *Riders of The Purple Sage* in four days. I read it with such avidity and total suspension of disbelief, that I was lost to everything except the fictional reality of the story. My nights were filled with dreams of gun-battles, and cattle-drives, and smoke-filled saloons; my days became a wonderfully confused, and confusing, mixture of reality and fantasy. The reality of having to do my chores around the farm; the fantasy of gun-slingers lurking behind every bush, and colourful, painted ladies twirling parasols, and picking their steps carefully along the creaking wooden boardwalks outside saloons with names like … The Golden Nugget, The Silver Slipper and Eldorado. The non-stop action, the snappy way the characters spoke to each other, the terse, evocative descriptions of a landscape so wildly beautiful as to be beyond comprehension or belief, invaded my youthful senses. At the end of that week I was suffering from some glorious, self-inflicted mental and emotional indigestion. I had made lists of words I had never seen before; magical, foreign-sounding words … *mesa, sombrero, gringo, pinto, butte, bandana, peon* … words that sang in my mind and whose meaning I longed to know.

From that first reading of Zane Grey I was addicted—as surely, as hopelessly—as if I had just been introduced to some rare and lethal drug. 'Mexico' wrote out for me, in his fine calligraphic hand a comprehensive glossary of words and phrases that further enhanced my reading and inflamed my already fervid imagination. I was, thereafter, able to invest any part of our glen I chose with all the properties of a Zane Grey scenario. Our lean-to hen-house in the haggard would become, in turn, the Bar C cookhouse, the town jail, or The Golden Nugget saloon. The rickety old cow-byre, standing out in stark relief on the western skyline, made a perfect livery stable, an approaching stage coach, or one of El Paso's many cantinas. At a pinch it could even become a herd of charging buffalo or an Indian raiding party silhouetted against the ever-changing cloud formations behind it.

There was absolutely no limit to the run of my imagination. With imaginary six-gun and rifle I shot from imaginary horseback everything that moved around our farm. Hens and turkeys scattered as I bore down on them at full gallop. I affected an American accent, similar to that of old 'Mexico' and the characters in *Riders of The Purple Sage,* enraging my long-suffering mother with my incomprehensible, slurred mumblings.

'Now you must 'scuse me, folks,' I would drawl after a hurried tea, 'I must git my six guns and mosey on down to the stage office. Thar's a stage a-comin' in from El Paso,' I added laconically, as I got a quizzical look from my mother and a broad grin from my father.

Whereupon I would be told, quite firmly, by my mother, 'Forget about the stage from El Paso and get your homework done.'

Or on Saturday mornings, when there was no school and homework could be left until Sunday, I would announce, quite casually, after breakfast. 'Think I'll saddle up the old pinto and ride over the mesa to Thunder Butte. Got me a feelin' them desperados who robbed Tuesday's stage are holed-up there. Jest might be able to flush 'em out.'

'Don't forget your sombrero,' my father would say, tongue-in-cheek, while my mother just sighed and mumbled something about … 'that 'Mexico' Mullins and his friend Zane Grey'.

I had also, with that unabashed mixture of arrogance and naivety only possible in the pre-teen years, begun to write a 'Western' myself. I filled page after page of two school-exercise books with my small, cramped handwriting, in a style that was a direct and unashamed imitation of the master—Zane Grey. It was, I remember, the story of an Irish farm-boy (myself, of course), who emigrates to the States and gets work as a ranch-hand in Arizona. Eventually, after proving himself a hero in countless gun-battles, he becomes foreman of the Bar Q, falls in love with and marries the Boss's only child, and eventually inherits the ranch. I called it *The Irish Cowboy* and though I cannot remember being conscious of this at the time, it was obviously my childish attempt to re-arrange Tom Mullins's life and give it a happier ending than he was experiencing as a farm-hand and itinerant chimney-sweep. However, that 'first novel' was never finished. The story-line became inextricably unmanageable, and I abandoned it. But

somewhere, I feel sure, among the many boxes of old newspaper cuttings and files in my suburban attic, those two old exercise books lie yellowing, buried under the detritus of the years.

Before going away to boarding school that September, at the end of what I think of now as 'the Summer of 'Mexico' Mullins', I had read three other Zane Grey novels: *Code of the West, Nevada,* and *To The Last Man.* And the old man had talked to me of his life in the States. 'An excitin' kinda life,' he admitted, before sadly adding, 'but all you took out of it at the end wus memories.' And to this day, I have never met anyone who took so much pleasure in working his way back along that chain of memory, link by link, as 'Mexico' did.

In 1900, when he was thirty-two, Tom Mullins, tired of hopping from one place to another, one job to another, had settled in El Paso. Ten years later, Zane Pearl Grey, four years older than Tom, had turned up at the ranch where Tom was by now foreman. Born in Ohio, Grey has been practising dentistry in New York City, having graduated from the University of Pennsylvania. He had abandoned that profession however to write 'Western novels'. He liked to research his locales personally; live, to some degree, the lives of the characters he was writing about. In any case the ranch foreman from Ireland and the 'dude' dentist/writer from Ohio became close friends: riding the trail together, enduring long weeks in the saddle on round-up and cattle-drive, drinking in the saloons and cantinas of the little border towns. Thereafter Tom Mullins received a signed copy of every book Zane Grey wrote. And Grey had a prodigious output—sixty books—before he died in 1939, at the relatively early age of sixty-seven. Two years later, Tom Mullins returned to Ireland, bringing with him a battered trunk

full of signed first-editions of his friend's books. They were kept under the trestle bed in the loft above the stable and to my certain knowledge, never shown to anyone but myself.

When I went to boarding-school that autumn I took two Zane Grey novels with me—*Arizona Ames* and *Wild Horse Mesa.*

'No more Zane Grey until you come back home for Christmas,' the old man warned, 'that way you'll have to git 'round to readin' the other book I gave you—*The Imitation.* '

And I did, during that first term at college, read a lot of *The Imitation of Christ,* but only after I had read, over and over, the two Zane Grey stories. Though I subsequently read *The Imitation* regularly, it was to be many years before I reached a state of maturity in which I could appreciate that a Kempis was a perhaps more important writer than Grey. But even then, as indeed now, I considered 'important' to be a very relative term. And though it does not reflect well on my character, I had and still have, a predilection for the old American teller of tales.

At the end of term, in our four-day pre-Christmas retreat, I became bored with the set spiritual reading; a recently published turgid text called *Where Am I Going?* by some Jesuit whose name I now forget. On the second day of the retreat I removed the loose dust jacket from this book and taped it neatly over *Wild Horse Mesa.* It was sombre, monochrome jacket—a close-up of a young man with a severe, ascetic, questioning Jesuitical face, on which was super-imposed an outsize bright red question mark. Very different from the colourful, action jacket of *Wild Horse Mesa* with its Indians in close pursuit of a lone cowboy. Though the Jesuit jacket was a little bigger than the Zane Grey, I thought I did quite a neat job

of camouflage, and with arrogant impunity carried it with me to the College chapel. It gave me a strange surreptitious thrill to think of all that action going on under the cover of an ostensibly serious book.

After Mass, on the third morning of the retreat, in a time set aside for spiritual reading I was walking in the cloister, lost in Zane Grey, when a heavy hand on my shoulder jolted me back to reality. Father Prior, well-practised in such stalking, had been tip-toeing behind me for long enough to know that the book I was reading was not what the jacket proclaimed it to be. When he discovered it was a Zane Grey it was immediately confiscated, and only given back to me on the morning of December 12th when we went home for Christmas.

At home bad news awaited me. In early November 'Mexico' Mullins had died. He had died peacefully in his sleep, in the loft above the stables at Roche's farm. I was very upset that this idiosyncratic old man, with whom I had talked so briefly, was gone forever from my life. My grandfather returned the two Zane Grey books to Bob Roche, the farmer for whom the old *ranchero* had worked.

Before returning to school in early January, I visited the old man's grave, as yet unmarked by cross or headstone. I was too young to appreciate the value of the box of Zane Grey signed-first-editions, left in the loft above the stables. I just felt sorry that now, with 'Mexico' gone, I would not be able to read the other titles. As a young boy brought up in a rural community and a tradition where children were taught to 'know their place', it never occurred to me then to dare ask the people at Roche's farm what had become of old 'Mexico's' books.

When I came home on holiday the following Easter, a small granite headstone had been erected over 'Mexico's' grave. He had left his meagre savings to my grandfather to take care of his burial and his memorial stone some months before he died. The simple message engraved on the granite had been composed by 'Mexico' himself, my grandfather told me, with blanks left for age and date:

Tom 'Mexico' Mullins
Aged 75 years
Died 11th November 1943
Friend of the writer, Zane Grey.

Years later, when I had finished my schooling and left the glen and gone to work in Dublin, I began to think again about those signed first-editions, and what had become of them. Had they been sold? Given to a museum or library? Not very likely. So, on my next visit home I talked with the son of the farmer for whom 'Mexico' had worked. Yes, he well remembered the old trunk under the trestle bed in the loft above the stables. And he remembered that it had been full of books; most of them, he said, were yellowing old paper-backs. Alas the Roches were not a reading family, so in the general clean-up of the loft, together with other odds and ends belonging to 'Mexico'—his threadbare clothes, his poncho, his sombrero— the books had been taken out and burned on the dung-heap in a corner of the stable yard.

Over the years I have often thought of Tom Mullins; of his wandering life and his lonely end, and of the touch of magic and romance he brought to the life of a small boy at a very impressionable age. I still read Zane Grey, dipping into the

copies of his novels bought in second-hand bookshops during my own wandering life.

I still have the copy of *The Imitation of Christ* which the old man gave me, but I must confess that I haven't read it for many years. The incurable romantic still lives on in me and sacrilege of sacrileges, to this day I prefer Zane Grey to a Kempis. And I often wonder what prompted the old man to give me, all those years ago, two authors so far removed in time and thought, style and subject matter. What prompted him, through all his wanderings, to keep them both in his personal collection? What other incongruous titles lay side by side in that old box under his trestle bed in his spartan quarters above the stables, when they took it out and burned it. I shall never know, this side the grave.

The Country of Standing Still

Thomas Merton

The late Sixties. Christmas week in New York. Unable to get
back to Ireland for the holiday, I was alone in the loneliest city
in the world; perfect fodder for the Irish 'party machine'.

But a week of eating, drinking, carousing, listening to the
interminable raucous renderings of *Galway Bay* and *Danny
Boy*, filled me with near panic. The prospect of the smog-filled
streets and the smoke-filled bars, and the tiny apartments
overflowing with inebriated expatriates, lost in their own
homesickness, made me look for an alternative.

I rang my friend, Thomas Merton, Father Louis, at the
Cistercian Abbey of Our Lady of Gethsemani, in Kentucky,
and asked him if I might spend Christmas there. His voice was
clear and unequivocal across the hundreds of miles of frost-
bound America. 'Of course, come right on down. Long as you
appreciate, see, that a Cistercian monastery is not the most
lively of places at Christmas. Far as I know we have only one
other guest over the holiday, see.'

It reassured me to hear the quick, almost staccato, no
nonsense voice, interspersing his speech with the little nervous
'see'. That was one of the first of his many endearing
idiosyncratic traits I had noticed when I first met him, two
years before. I had gone to the monastery for a few days retreat

and, having read many of Father Louis' books, had asked Father Guest Master if I might have a meeting with him. Though a busy man—he was Novice Master, writing books, and lecturing at the time —Father Louis agreed to see me, and came next afternoon to the Guest House. We walked in the woods behind the sawmill and talked for over half-an-hour. I sensed an instant rapport and after that first meeting I had been back to Gethsemani twice, meeting him on both occasions.

When he told me there would be only one other guest I began to assure him that that was exactly what I wanted, after the suffocating atmosphere of New York, and I was already visualising the Guest House parlour with its great log fire. I asked about the Kentucky weather.

'We had a big fall of snow two nights back, see. From where I'm sitting here at the phone I can see the 'knobs' out back of the sawmill. Snow's all drifted against them. Funny sculpted effect, see. We've never had snow when you've been here before, have we?'

Before I could answer his question, his infectious enthusiasm had taken over, and he was off on a detailed instruction of how to get there in these weather conditions.

'You always flew down before. Well, the airport's closed now, see. Likely to be for another week, they say. So, you'd better come on down by rail. Overnight in Cincinnati, see. You'll love the Ohio countryside.'

He didn't mention it on the phone, but that was the route he had once taken himself, when, disillusioned with New York and his life there, he had first visited Gethsemani, seeking an antidote to the senseless hedonism of the big city. For him the

antidote was to be permanent; for me it could only be temporary.

Two days later I left New York for Kentucky, to spend Christmas with the Cistercians. I went by train, as Father Louis had suggested, in the very early morning, from Grand Central Station. Driving across town the deserted streets were bandaged in a thick fog, but even the fog could not hide the ugliness of the glass-and-concrete canyons.

As we cleared the suburbs I could discern the vague bulk of low hills in the pale light. Listening to the trundling of the train and the monotonous clack-clack of the wheels, I began to recite to myself lines from one of Father Louis' poems:

> *Look where the landscape, like a white*
> *Cistercian,*
> *Puts on the ample Winter like a cowl*
> *And so conceals, beneath the drifts as deep as*
> *quietude,*
> *The ragged fences and the ravaged field.*

The peacefulness of the poem, the noise of the wheels, and the monstrous wash of wind as we sped through the morning gloom, all conspired to work some special kind of hypnotism, and I fell asleep. When I woke it was full light and we were deep into Ohio. The Ohio countryside was as lovely as Father Louis had said. In Northern Ohio the snow had only just begun to thaw, and drifts still piled, like great white gashes, in the lee of the long, brown, rolling hills. And in that moment, I began to fear, with an inordinate, childish fear, that the Kentucky snow too would have thawed before I got there. However, leaving the train at Cincinnati where, as Father Louis had suggested, I would overnight, my fears were allayed. I met a

man going North for Christmas, who told me that all of Southern Ohio, right into Kentucky, was still under snow.

Late in the evening of the second day I reached Gethsemani. Daylight had already gone when I left the train at Bardstown Junction, and took a taxi to the monastery. A Christmas moonlit the Kentucky countryside. It touched the snow, drifted against the Kentucky Hills or 'knobs' with an ethereal, bluish light.

The monks were all in choir when I arrived, chanting the last Office of the day, Compline. After paying off my taxi I stood in the moon-drenched snow and watched the soft, warm light spilling from the church windows. It fell in a series of long, yellow bars across the blue-white snow. The sonorous plainchant ceased, and standing in the silence under the great vault of the Kentucky sky, I listened to the thin wind polishing the moon and bright stars. A scene straight out of Father Louis' poem 'Advent':

> *And intellects are quieter*
> *Than the flocks that feed by starlight ...*
> *O white, full moon, as quiet as Bethlehem.*

Father Louis greeted me with his usual bear-hug, and as the community was now retiring for the night, led me through darkened corridors to the Guest House. He whispered that he would see me in the morning and we would talk then. He also confirmed that there was just one other guest. He would introduce us in the morning also. Then he was gone and I could hear the soft swish of his woollen habit as he hurried away.

I was wakened at four a.m. next morning, Christmas Eve, by the great bell of Gethsemani, calling the monks from sleep

for the first Office of the day and all the early Masses. Stumbling, half-asleep, down the dimly lit corridor to the church, I heard the click of a typewriter in one of the guest-rooms. My fellow-guest, I thought, must be a writer.

That first Office, or Night Office as the Cistercians call it, is one of the most moving moments of the whole Cistercian day. Heightened by the early hour, the dawn breaking on the windows, the first stirring of the birds, their tentative song, Merton himself found the period immediately afterwards a fine time in which to write. Lines like those from his poem, 'After The Night Office, Gethsemani':

> *It is not yet the grey and frosty time*
> *When barns ride out of the night like ships:*
> *We do not see the Brothers, bearing lanterns,*
> *Sink in the quiet mist,*
> *As various as the spirits who, with lamps, are*
> *sent*
> *To search our souls' Jerusalems …*

Round about mid-morning, on Christmas Eve, Father Louis and I went for a long walk through the woods. He wanted me to see his 'hermitage'. As we walked the slightest touch sent little avalanches of powdered snow cascading from the branches of the trees. Father's white, woollen habit, which had looked so startlingly white in the dark the previous night, looked a shade of cream now against the stark white of the snow.

From previous talks I knew he liked to sound-off a bit about James Joyce, and his views on the writer were always, to say the least, idiosyncratic and original. So as we walked, I

broached the subject by asking if he had been reading much of Joyce since my last visit.

'"The Dead",' he answered, enthusiastically. 'Been trying to read that, see. But it's a curious story. The writing's so good, but the story is so damned dull, see. And that speech at the party, the one everybody seems to like so much, well, that's just pure corn. The end, I suppose, was kind of pretty, see. So maybe,' and here he laughed, 'instead of writing a story, see, old Joyce should have written a poem. About the snow falling endlessly through the universe, and all that, see. But as a story, no, not for me ...'

I smiled to myself. His answer proved two things. Two things I already knew from our previous brief talks. Father Louis knew his Joyce, and if you didn't want an honest answer then you shouldn't ever ask him a question. We had reached the little flat-roofed, block chalet that was his 'hermitage'. Before going inside we had to kick our boots against the step to shake off the accumulated snow. And we brushed the powdered snow that had fallen from the trees off our shoulders. Father Louis flashed me one of his mischievous smiles, and asked me an enigmatic question to which he knew there was no answer ... 'Tell me, Bill, are there still Irish people who believe that Shakespeare was really a man named O'Neill?'

Before lunch Father Louis introduced me to my fellow-guest; the one I had heard typing in his room that morning. He was indeed a writer; Erskine Caldwell, author of *Tobacco Road, God's Little Acre, Georgia Boy, A Lamp For Nightfall* and several other books. He was a simple, affable man, who from the very start insisted I call him 'Skinny'. 'Damn sight easier to git your tongue round than Erskine,' he said.

Skinny Caldwell and I got on well. After lunch we went for a long walk together out across the snow-covered fields. He assured me he had not come to Gethsemani out of some deep spiritual need or conviction. He had come to visit Charlie, an old friend who had once worked with him when he was a reporter on *The Atlanta Journal*. Charlie had, some years back, 'got religion' and had ended up a member of the community at Gethsemani Abbey. Skinny liked to visit him twice a year, and also enjoyed the stimulus of Father Louis' company for a few days. And he confided to me, the peace and quiet of the place made him forget his loneliness and insomnia for a while. At this particular time he was trying to recover from his second divorce.

He told me of the time, before he began to write fiction full-time, when he had worked with Charlie on the *Journal* in Atlanta. His insomnia went right back that far. Working as a reporter all day, he would work late into the night writing short stories, and lost the 'knack' of sleeping. He told me of the Features writer who worked with him in Atlanta.

'She was the best feature writer I've ever known, was Peggy Mitchell. Peach of a girl and peach of a writer. When she suddenly decided to leave, to write a novel she'd been talkin' about for years, the Editor flipped. Read her the riot act and told the rest of us he hoped we'd never be so foolish as to leave a steady job to write 'fool' fiction. Well, nobody heard from Peggy for two or three years, then she surprised us all by publishing that big novel she'd always been talkin' about— *Gone With The Wind.'*

Between talking and walking we had gone further than we intended, and when we turned to come back the daylight had

begun to fade. Already lights were coming on in the monastery. In the half-light it looked like the outline of big ship adrift on a sea of snow, bulking huge across the snow-fields. Our breath hung, half-frozen, in the below-zero air. The Vesper bell was ringing and monks were coming in from their various work stations, all converging on the monastery choir. I remember asking Skinny if he knew Father Louis' poem, 'Evening: Zero Weather'. He did not; had read some of Merton's prose, but none of his poetry. It is a long poem, but I could remember some of the lines and recited them aloud as we walked, to the accompaniment of our slow gumboots crunching on the frozen snow:

> *Now the lone world is streaky as a wall of*
> *marble*
> *With veins of clear and frozen snow.*
> *There is no birdsong there, no hare's track,*
> *No badger working in the russet grass:*
> *And all the bare fields are silent as eternity.*
> *When all the monks come in with eyes as clean*
> *as the cold sky ...*

'How can you remember it, just like that?' Skinny asked, amazed.

I was about to laugh and make some trite remark, but I sensed this was a man with whom, after just a short acquaintance, I had a genuine rapport, so, to use his own vernacular, I levelled with him.

'Because I love the poetry, and the man.'

Skinny nodded. 'And so do I,' he said, and we walked on in silence. I know he understood.

After Vespers Skinny Caldwell and I sat at the big log fire in the Guest House parlour. We were silent for a long while, watching the flames flicker and flare and die again; each of us with his own thoughts, his own loneliness. He was first to break the silence.

'Ye know, I'm just about gettin' over this second divorce,' he said, taking a log from the basket and throwing it on the fire. A shower of sparks flew upward. He continued, sadly, 'Lonely business divorce.'

Just then Father Louis came into the room, and hearing something of Skinnys' last remark, said, 'Say, what's all this about loneliness, see? Don't talk to me about loneliness. Know all about it, see. Sometimes I think I'm some kind of Santa Claus of loneliness.'

'That may be,' Skinny said, 'but you've got all this peace and solitude here in Gethsemani, Father Louis. That, surely, must help. Now out there in the world is very different.'

Father Louis, who had been looking out the window, turned slowly to face us now, and there were tears in his eyes. His voice was soft, less staccato, as he spoke ... 'But surely, Skinny, solitude is not something outside you. Not an absence of men or sound, see. Isn't it really a kind of abyss opening up at the centre of your own soul? And the only way I know how to find that kind of solitude, see, is by hunger and thirst, sorrow and loneliness. The man who has found such solitude is really empty, see. He has advanced beyond all horizons. There are no directions left, see, in which he can travel. For this is a country whose centre is everywhere, and whose circumference is nowhere. You don't find it by travelling, see, but by standing still.'

We were, all three of us, silent after that for a long time, listening to the fire crackle and the resin hissing, and the thin wind rattling the wooden shutters; each of us lost in his own separate country of standing still.

Late that night, Christmas night, alone in my room, I stood by the window, looking out at the bright, starred Kentucky sky, and the undulating snow-covered 'knobs', luminous under the moon. The great sleeping monastery was silent; an island in a sea of snow. There was no movement, no sound. Only on the virgin snow of the garden a thin line of tracks some small animal had left in passing. I thought of Skinny Caldwell down the corridor, alone with his demons of insomnia and the loneliness of divorce. And I thought of Father Louis at the far end of the monastery, alone too. Before going to sleep, I whispered a few lines of his to the close and holy darkness:

> *November analysed our bankruptcies, but now*
> *His observations lie knee-deep beneath our*
> *Christmas mercies: while folded in the buried*
> *seed,*
> *The virtual Summer lives and sleeps.*

I never saw Skinny Caldwell again after that Christmas at Gethsemani. He died in 1987. But I did see Thomas Merton, just once more in the spring of 1968, the year in which he died, when I went down to the Abbey for a few days' retreat, a respite from the pressures of New York.

I was shocked to find how his health had deteriorated. He had been suffering a lot from stomach trouble, and from severe back pain. And the pressure of being so well-known as a writer, and all the consequent requests to write pieces for this or that publication, had begun to take their toll. He had always

been a very conscientious letter-writer, and had, all through his monastic life, carried on correspondence with people all over the world. Some of them eminent writers, painters, philosophers; others ordinary people who had simply written to him, and whose letters were invariably answered.

For many reasons, his plans to visit his one-time novice, Ernesto Cardenal, at his lay monastery in Solentiname in Nicaragua, had not worked out. He was now looking to the East, to India and Tibet, and planning a trip there in the autumn.

As we walked in the woods that afternoon, I could see he was depressed and disillusioned about many things. As I looked at him, I was reminded of how his friend, Daniel Berrigan, had recently described him as 'A man crazed with caring about the human condition; a voice crying forever into the North wind of indifference'. The previous week some fanatical Catholics in Louisville had burned copies of his books in public, declaring him an atheist because he was so strongly opposed to the Vietnam War. That, to him, was incredible.

'The hypocrisy of it all, see, is what gets to me,' he said, as we stood against a fence looking out across the lush, new Kentucky blue grass waving in the wind. 'When I think that every morning in the Pentagon several Masses are celebrated, see, and attended by people who go directly from Mass to sit at desks, see, and plan the destruction of their fellow-men, I get really upset.'

But then, like the wind passing over the grass of the meadow, his depression seemed to lift as quickly as it had descended, and he was his old ebullient self again, changing the subject.

'Say, Bill, you ever been to The Cloisters in New York?'

'No, never heard of the place. Where in New York?'

'Uptown. Near the Palisades. Just above the river, see. Saved my life when I was a student at Columbia and thinking about becoming a Catholic, and trying, see, to stay sane in a crazy place like New York.'

'What is it?' I asked, 'some kind of monastery. A shrine?'

'Both. It's both, see. Kind of monastic museum. Tell you all about it before you go back. Be a good place for you to go, see, when the pressure builds.'

Next morning, after breakfast, Father Louis came to my room and showed me an old black and white snapshot of The Cloisters. It was like the replica of some old monastery cloister, only standing near the Palisades and surrounded by trees in the corner of a little New York City park. He became quite excited telling me its story. In fact it was no replica, but the actual cloister of the monastery of Saint Michel-de-Cuxa, a centuries-old French foundation in the Pyrennes. It had been dismantled, stone by precious stone, and shipped across the Atlantic by some French-American cultural foundation, and re-built in a corner of this little park above the Hudson. It had a special meaning for Father Louis; he considered it some sort of good omen, when he had first heard about its existence, in those far-off times of great personal inner conflict. You see, when he was growing up in the Pyrennes where he had been born, Saint Michel-de-Cuxa was one of the many ruined monasteries in the hills across the valley. He would often, as a boy of six or seven, go out for picnics with his painter father into those hills, and his father would sketch the ruins of the old cloisters.

'My God,' he said, 'little did I know that years later those old stones, see, would follow me across the Atlantic to New York, and be there for me, see, at a time when I so badly needed them. You know, those old stones, those centuries-old monastic stones, still carry a kind of charge, see. Give off a kind of energy. You must go and see them.'

And I did. The following week, on my first day back in New York, I took some time and went uptown to The Palisades. I found this little bit of ancient, monastic France as beautiful and atmospheric as Father Louis had described it. There was a certain incongruity about these ancient stones from Canigou, reassembled in this neat, urban park, so close to all the frenetic activity of the city. But the little cloister had preserved its character; its stones did indeed have their own charge, and their very presence accused all the hideously characterless high-rise buildings that towered about them. I regularly went back to The Cloisters, or St Michel de Cuxa as I preferred to think of it, during the rest of my time in New York. It became a kind of oasis of peace and quiet for me, helping preserve my sanity, as it had Thomas Merton's.

On my last evening at Gethsemani I was reading in my room after Vespers, when Father Louis came to say goodbye. He had a consultation in Louisville next morning; something to do with his on-going stomach problems, and I was leaving from Bardstown Junction on an early train. So, we would not see each other again this visit. Indeed, though I could not know it then, we would never see each other again.

He noticed a copy of Pasternak's Doctor Zhivago on the table beside my bed.

'You like Pasternak?' he said.

'Yes, very much.'

'Good, good! He is the one truly great writer of our time, see. You must know that. Read him. Read him all the time. There was this great sense of urgency about Pasternak, see. He saw reality as something which must be caught as it passes, see, something which must sweep us away with it. He hated the abstract. Used to say, if we pause, even for a moment to formulate abstractions, see, we will have lost life as it goes by, see.'

And there and then, I was making another promise to Father Louis; a promise to read Pasternak, over and over again. For he was that kind of extraordinary person, Father Louis. So full of enthusiasm for the people and the things he loved that he imbued you with the same sense of excitement. It was impossible to say no to him.

On December 10th of that same year, 1968, Thomas Merton, attending a conference for monks of both Christian and Buddhist traditions in Bangkok, was accidentally electrocuted by a faulty, free-standing electric fan. At fifty-three, this Colombus of the spirit, this true Renaissance man, was but coming to the full flowering of his many talents.

I was in Dusseldorf at the time and heard the news of the tragedy on my hotel-room radio. Shocked and incredulous, I cancelled a dinner appointment. I needed to be alone, and went out to wander aimlessly about the streets in the comforting darkness. It was difficult to accept that the dynamic, life-loving Father Louis was dead.

After walking for a long time I found a dimly lit church in a side street, and went in and sat before a flickering sanctuary lamp. Multiple images of Merton, layman and monk, flooded

my bewildered mind; the early-orphaned child, the precocious, often obnoxious adolescent, the student, the convert, the Trappist monk, the hermit, the prolific man of letters, the social reformer—concerned with war and peace and social justice— the tireless seeker after parallels between Asian and Christian monastic traditions.

Before leaving the church I went across to a side altar, where candles were burning before a shrine of Our Lady. I lit another and found a place for it on the warm, wax-encrusted candelabra, remembering as the odour of melting wax and burning wick hit me, the lines from Merton's poem on Death:

> *Yet all my power is conquered by a child's Hail*
> *Mary,*
> *And all my night forever lightened by one*
> *waxen candle.*

And on my way back to my hotel, a sudden, unbidden image came to me, of Merton and myself, high-stepping through the snow on our way to his hermitage in the Gethsemani woods.

The Surgeon-Painter of Patrick's Bend

Dr Patrick Joyce

During the early 1960s in America, I worked one summer in Bismark, North Dakota. There the wide Missouri River forms a natural boundary between America's East and West. The banks of the river might well be a hundred miles apart, so different are the landscapes on either side.

On the Bismark side the land is typically Eastern; bucolic countryside, all grass and green foliage, with groves of trees right down to the water's edge. Across the Missouri, on the Mandan side, the land is Western; burnt, brown grass, water-scorings, and outcrops of bare rock. This is the northern extremity of the Badlands, the arid country stretching from Nebraska northwest into Montana. This is a territory dotted with surrealistic buttes and rolling tumbleweed; where the scattered bones of dead animals are picked clean by buzzards forever circling in search of carrion. Aptly named, the Badlands is a dry and desolate place, a place to fill the traveller with foreboding.

I lived on the Bismark side, the Eastern side, and on my way to work every morning, passed a large brick house, built on a bluff above a gentle bend in the river. It was a bright, well-kept, cheerful place, surrounded by large, neat, colourful

gardens. A carved granite stone set into one of the entrance piers proclaimed it to be 'Patrick's Bend'.

From the start I sensed an Irish connection, and I was not wrong. On making discreet enquiries I found it to be the home of a Doctor Patrick Joyce, a retired surgeon, then aged eighty-four. Born in Clifden, Connemara, he had settled as a young doctor in Bismark shortly after the turn of the century. He had become part of the folk-history of the place; one of the best-loved men in town; revered both as a surgeon and as an artist. He was a painter of exquisite talent, and was still, when I met him in his retirement, producing magnificent oils.

I saw Pat Joyce perhaps half-a-dozen times during that summer in Bismark; and it all began with my having the nerve to drive up the winding, gravelled avenue to 'Patrick's Bend' and ring the door bell. A elderly housekeeper with a friendly manner and a strong Irish accent showed me into a big bright lounge overlooking the river. She needed to know nothing other than that I was Irish, and went away to tell Doctor Joyce of my arrival.

Within minutes the Doctor appeared, dressed in an old white smock, stained with all the colours of the rainbow. I must forgive his appearance he said; he had been painting. He was tall, over six feet, thin and straight as a ramrod, with a veritable mane of silver hair and a well-trimmed goatee. His incredibly lively, dark-brown eyes made him look much younger than his eighty-four years. He was overjoyed to meet someone from Ireland. Bismark had never attracted Irish settlers and over his years there, contact with the old country had been tentative. The occasional letter from some relative, or some

contemporary; the odd Irish tourist; or some emigrant, like myself, temporarily domiciled in Bismark.

That first visit lasted over an hour, and we talked mostly of Clifden and its hinterland. He would ask me a question and then, such was his love for the place, so avid was he for news, he would start into another question before I had framed an answer. I was surprised to find that a man who had spent more than half-a-century there in Bismark, had never lost his West of Ireland brogue. There was not the slightest trace of American idiom or accent. I noticed particularly that when he said Galway, the 'y' disappeared, the end of the word flattened out in a soft double 'a'. And his 'e' often became 'i', as in whin and thin, for when and then. There was nothing affected in this. I imagine it was born out of a resolution, made all those years ago, to preserve his Irish identity, never affect an American way of speaking.

From that first meeting Pat Joyce struck me as a man who knew very definitely who he was, and who was determined to stay true to himself. Would to God that some of the Irish I met in America, particularly in such large conurbations as Boston and New York, could have been the same. Some of them, after a few months of working and living in urban America, spoke in an accent and an idiom that was so alien it was unintelligible. Their self-esteem and self-confidence having reached the nadir, it was perhaps only natural that they should capitulate and try to imitate the American accents all round them.

For reasons I never discovered, Patrick Joyce had never married. He laughed and said that he had always been too busy; just as he had been too busy to ever go back to Ireland even for a visit. Though, he admitted with a hint of regret, he

had on several occasions planned to go back, but there was always some crisis to upset his plans. He had not seen Connemara for over half-a-century.

Imagine my surprise, then, when he took me to his studio, and showed me more than a hundred canvases, ready to be framed, for an exhibition in St Paul. And all of them were of the Connemara he had not seen for so long. Magnificent paintings of bogland, lake and mountain, and the wild Atlantic Coast around Clifden. Here in the big studio looking out across the Missouri and the buttes of the Badlands, in some wonderful incongruity, were enormous canvases of The Twelve Pins, Clifden, Maam Cross, and Leenane; brown bogs with their pools of luminous water; surf-ringed rocks on the remote archipelago near Slyne Head Lighthouse; the coast road at Roundstone; the Sky Road at Clifden. And in almost every painting, there was the inevitable running flame of wild fuschia; sometimes a mad, exaggerated riot of it; sometimes a subtle whisper in the green of a roadside hedge. All remembered from Patrick Joyce's childhood and boyhood: never again, for him, to be seen in reality, but still living and vibrant in the wonderful kingdom of his imagination.

His style, he told me, had been influenced mostly by the Impressionists—Rouault, Matisse, Seurat, Gauguin, and Van Gogh. And it certainly showed in his paintings; the mixture of subtlety and strength, the confidence or rather the sheer prodigality, the abandon, with which the paint had been used. These great canvasses of the West of Ireland landscape and seascape, glowing with strong colours, often took on a three-dimensional effect. In one, a skylark ecstatically soaring high above the bogland seemed to hang in space, outside the canvas. In another, a white road disappearing over a hill seemed to take

off into some unseen, sunlit countryside beyond the canvas. Like all great paintings they didn't simply depict a scene; they suggested a whole landscape, a whole life, outside the parameters of the canvas.

Patrick's early days in Bismark had been devoted solely to the practice of medicine. He had discovered his talent for painting only in the mid-Thirties. Thereafter, he had managed to combine the two by a strict adherence to a work-plan so spartan as to be unacceptable to most people. But he said, he loved medicine and he loved painting, which meant rising every morning at 5 a.m. and working through to midnight. His painting had to be accommodated between his surgery hours and his work in the operating theatre of a local hospital. Looking at a huge, unframed canvass of the bogland just west of Maam Cross, he smilingly told me that it had been finished one spring morning between the planned removal of a banker's gallstones, and the unplanned removal of four bullets from the legs of a local saloon owner, shot in a family feud.

He had always worked on two canvasses; one on an easel in his studio at 'Patrick's Bend', the other on an easel in the corner of his office at the hospital. With that *modus operandi* he was able to utilise every spare moment that offered; able to deploy his twin talents to the best possible advantage. He was able to go directly from his easel to the performance of some delicate surgical operation, or conversely, leave the operating theatre and go straight to his easel. 'You see,' he explained, 'surgery is really a combination of science and art, and painting a combination of art and science. And I've been lucky enough to be blessed with some little talent for both. They complement each other perfectly.'

His paintings were so good that I once asked whether he had ever considered abandoning medicine and devoting himself to art. Had he been a bad painter or a bad surgeon, or a dabbler at one and a master of the other, I would not have dared ask the question. But he was widely acknowledged as a fine surgeon while, at the same time, having a huge reputation as a painter. He admitted that he had considered giving up medicine, but after a lot of soul searching had decided against it. 'I felt,' he said, 'that I had to have the two occupations in order to vary the great pleasure of working without tiring or getting bored. I go to one, tired from the other, and am instantly renewed by the different challenges presented.' Sometimes concerned friends had warned him of the dangers of overwork. But he had scoffed at this. 'People don't ever die of overwork,' he said, 'but they do die of apathy.'

Did he ever paint anything but Connemara? He hesitated before answering: 'Yes, for a short period.' Then he went on to tell me of his early days in Bismark, when the Badlands were still quite literally just that—a veritable battleground for rival gangs of outlaws. Bank and stage-coach robbers, rustlers, murderers and rapists roamed the range. Many of his first patients, after he set up practice, were badly shot-up renegades, ferried across the Missouri by their buddies and dumped on his doorstep under cover of night. He had invariably looked after them. Some died, some recovered and went back across the river to take their chances again. Sometimes he had been called from his bed and taken across the river to minister to the wounds of someone too ill to be taken to him. Fascinated by the lunar landscape that spawned such people, he had for a while painted it and them. Large canvases. He seemed to have

a penchant for painting large pictures; whether of North Dakota or of Connemara.

In all he had painted more than sixty of these Badlands pictures. They were nearly all in private collections throughout America. Some few had gone to museums or galleries specialising in artefacts from the Indian wars and the old Wild West. He showed me some colour photographs of these paintings. Covered wagons drawn up in a circle, surrounded by redskins on horseback; two gunfighters, walking toward each other on the dusty main street of some one-horse town, hands poised above their guns, in that moment before the draw. Cowboys and Indians in a variety of poses and situations. But always—and he smiled as he drew my attention to this— always mountain peaks; sometimes blue, sometimes white with snow. Sometimes up close, more often at a distance; glimpsed over the rooftops of the ramshackle buildings of a town; seen as the backdrop to some lonely ranch-house on the open prairie. 'If you look closely, and for long enough,' he said, laughing, 'you will see how like the Twelve Pins all my mountains are. I could never get away from those hills of home!'

At eighty-four he was still in good health, living in hope that the severe arthritis, which had begun to stiffen his legs, would not effect the hands that had worked so many wonders with the surgeon's knife and created so many beautiful paintings. His surgeon's work was done when I met him, but he still had countless pictures he wanted to paint.

After that summer I never saw the surgeon-painter of Patrick's Bend again. Eight years later, when I returned for a brief visit to Bismark, he was gone. The old brick house on the

bluff above the river had been modernised beyond recognition by its new owner; the victim of what I always think of as 'conservatory architecture'. Little additions here and there, all glass and chrome; an affront to the grand old building where the man from Connemara had lived so happily, and for so long.

The new owners told me Doctor Joyce had gone South five years ago, to live with Irish relatives somewhere near Baton Rouge, Louisiana. I was about to ask them if the old man's hands had stayed free of arthritis, but did not. I preferred not to know. I preferred to think of him, his gifted hands still delicate and supple; still painting the big, bold, magical canvases of a countryside he had not seen for three-quarters of a century, but which he remembered in every singing detail.

And often since, driving on that lovely mountain road in Connemara that winds between Clifden and Leenane, I round a bend and see a mountain peak against the sky, and have a strange feeling of *déjà vu*. I have seen this peak before, with the clouds piled up behind it, in one of those huge canvases in a studio above the loop of the wide Missouri.

The Troubled Heart

T.H. White

Toward the close of 1944, when the end of the War was imminent, my father took me to Dublin for the first time. I remember the exact date, Saturday December 16th, because on arrival in Dublin we heard that the famous band-leader, Glen Miller, was 'missing, presumed lost'. We stayed for a few days with relatives in Blackrock, visited the National Gallery and the National Museum, several bookshops, bought Christmas presents in Clerys, and visited a pub on the Quays, where I had a 'brief encounter' with T.H. White—exile, author, falconer and conscientious objector.

We had travelled by rail from Waterford, a distance of just over 100 miles. I was twelve years old, and the journey seemed quite epic to me then; as if I were setting out on safari, and might never reach journey's end. It was the first time I'd ever been in a train, and the longest journey I'd ever undertaken would have been that from our remote glen to the seaside town of Tramore, a distance of five miles. And that would have been by horse-drawn trap.

Indeed, our journey that cold, clear morning from the glen to Waterford Railway Station was by horse-drawn trap. Leaving in the pre-dawn darkness we reached Waterford with the first light, in time to catch the early train. Driving through

the sepulchral streets, my father pointed out to me, inside the low walls of a public park, the dark-brown bulk of dozens of enormous ricks of turf. Seen in that half-light they reminded me of the convict hulks from Dicken's *Great Expectations.* My father explained that they were built of the turf cut by the Army on the bog near our house. From them the townsfolk drew their fuel-ration every week.

Though I did not quite appreciate it then, rail travel being by steam-driven engine, and steam being dependent on keeping a good fire going to heat a boiler, and fuel—of any kind—being at a premium during those dark war years, it was not certain when, if ever, we would reach Dublin. However, reach it we did; but not on time and not without incident. On that particular day they used a mixture of coal and turf. Only the turf was sodden and the unfortunate fireman had great difficulty just keeping it alight, never mind raising a head of steam.

So we chugged slowly along through the dreary, wintry countryside, at every scheduled stop taking on board baskets of supplementary fuel, collected by the local Station Master and his family; their contribution to the war effort. This gave the dying fire a temporary fillip and carried us forward, chugging and hiccuping to the next stop. Except once, on a slight gradient, when the engine came slowly to a halt. Driver, fireman and guard had to climb down and scavenge along the hedges that bordered the track for whatever pieces of timber they could find to help revive the faltering fire, boost our boiler-power and get us going again. We reached Dublin over two hours later than the stated time of arrival.

But even more memorable than that epic rail journey was my brief encounter with T.H. White. White's name and work had been known to me from my early days in the National school. My teacher was, among other things, an alcoholic; though, at the tender age of six or seven, I didn't know what an alcoholic was. I was just conscious of the fact that he was a man of swiftly changing moods. They swung from great, bellowing rages, when he shouted at us in a voice that thundered, to lovely lagoons of calm when he sat, semi-somnolent before the turf fire, and in a voice that caressed the words, read to us from, among others, T.H. White.

That first teacher was a great communicator despite his vacillating moods, instilling in us a great love of words; the wonderful uses to which they could be put; the wonderful effects they could create. He was a kindly man really; a talented man who, like so many talented people, had his faults. But he also had, though as a pupil I was too young to understand that, the virtues of his faults, and that inestimable double gift of sensitivity and imagination.

I remember in the late 1930s and early 1940s listening to the great White books about King Arthur and the Knights of Camelot—*The Sword in the Stone, The Witch in the Wood* and *The Ill-Made Knight.* So enraptured was I by those books that, after the teacher had read each one to us, I would borrow it and take it home to read myself, by candlelight, little knowing that I would, on my very first visit to Dublin, actually see T.H. White in the flesh.

We were—my father and I—on our way to Kingsbridge to get our train back home. At the corner of O'Connell Bridge my father explained that on his visits to Dublin he always called in

to say 'hello' to an old friend from Waterford, who worked as a 'curate' in O'Meara's Pub on the nearby Quays.

It was mid-afternoon and the pub was quiet. While my father drank a pint, and talked with his friend behind the bar, I was 'parked' on a high stool at the end of the counter and given a large glass of lemonade. There were few other customers. A countryman and his wife at a table, surrounded by parcels, like ourselves waiting for a bus or going to catch a train. They sat silently, each with a whiskey before them on the tiny table, and a sad, faraway look on their faces, so 'apart' that each might have been waiting for someone else.

The only other customers sat at a large table in a corner near my end of the bar. Four men, engaged in intense conversation. Two of them pretty ordinary; the third, large, middle-aged; the fourth, younger, a veritable giant, his great height and bulk accentuated by his wild, tousled hair and untrimmed beard. They all drank whiskey, with a bottle in the centre of the table, from which they replenished their glasses as quickly as they emptied them. What my father always referred to as 'serious drinkers'.

Now, from as far back as I can remember, I have always had a penchant for eavesdropping. It was as if I knew, from a very early age, that one day I would be a writer, and that these overheard conversations, these remembered impressions, would be the bricks and straw of my future 'stories'. Unlike other writers I have heard about, I never, either then as a child or later as a professional writer, made notes. I always worked on the basis that if what I was hearing or overhearing was worth remembering I would remember it; if it wasn't worth

remembering I would forget. I remember the conversation from that table in O'Meara's quite well.

'I know it's difficult, Tim,' said the middle-aged one, in great seriousness, 'but you must come to terms with it.'

'I appreciate that, Bertie, old man,' replied the bearded one with a very strong English accent, adding despondently, 'but death is never easy to accept, is it? Especially when you're as close as I was to Brownie.'

'Never,' said one of the other two, 'never.'

'Still,' Bertie insisted, 'you'll just have to try. How long ago was it?'

'Two weeks. Haven't slept a full night since. Some nights I go and sit all night by the grave.'

'Your writing will suffer, you know,' warned Bertie.

'I know, I know, but I'm helpless, bloody helpless,' said Tim, beginning to cry openly, stammering, 'never get over it, never.'

At this point they had attracted my father's attention and he asked his friend the barman who they were.

'The big fella with the beard is that English writer T.H. White, the others are friends of his from across the road at *The Irish Times*. They've been in a while. Drownin' their sorrows. Someone belongin' to the big fella died recently.'

'Who's T.H. White, anyway?' said my father.

Agog now with excitement, I wanted to tell him I knew, but the barman beat me to it.

'Ah, he wrote them books about King Arthur. He's supposed to a conscientious objector. Lives down in Meath somewhere. Came over here when the war started. If ye ask me

he's just sittin' it out down in the country 'til the whole thing's over.'

'Well,' said my father, 'according to the latest news he shouldn't have too long more to wait.'

And then he was collecting our things and calling me down from my stool and we were on our way to the station. At the time there was no question of my having the temerity to slip off my stool while my father and his friend talked, and go to the table and say 'I've read some of your books!' But, oh so often, in the fifty odd years since then, I have wished I'd done just that. However, a child's place in those far off days, as I was so often told by my elders, was to be seen and not heard. So the good moment went.

After the Christmas holidays, when I returned to school, I told my teacher. Not my idiosyncratic, eccentric, alcoholic one from the National School, who had introduced me to the T.H. White books, but a Christian Brother at the new school to which I had transferred the previous autumn. He showed no interest. Indeed, I wonder if he even knew who Tim White was. My old teacher would have reacted so differently, I thought, but he had by then 'retired'. It was only many years later that I discovered 'retirement' had been a euphemism for his being sacked, after which he had left the parish to go to die slowly in a home for alcoholics. I have since often wondered how, with all my youthful interest in people and my penchant for observing things, I never once, in all the years he taught me, even suspected he was drinking.

I have since read many of White's books, but it was not until 1959, reading his *The Godstone and the Blackymor,* that I realised 'Brownie' had been a dog. That was, at least, part of

the mystery of Brownie solved—the identity. But as to the circumstance of Brownie's death, I had to wait until much later—1967 to be exact—when I read the wonderful biography of White, by Sylvia Townsend Warner.

Two weeks before I saw the writer in Dublin, Brownie had died at Doolistown House, near Trim, in Co Meath, where White was a paying guest for the duration of the war. He had just finished the manuscript of *The Elephant and the Kangaroo,* and had gone to Dublin by bus to send it off to his publishers in America. He was away from her for only nine hours, but during that time she had, as he described it in his 'Notebook': 'one of her annual attacks. I could have saved her, perhaps. The people here didn't understand her.'

To appreciate the extent of White's grief it must be understood that, for many years, his dogs and falcons had come to mean much more to him than humans. Very early in his adult life he had decided that it was much more satisfactory to give his affection to animals. He felt animals never let you down; humans invariably did.

In 1964, nearly twenty years after he left Ireland, White sold the film rights of *The Once and Future King* to Hollywood for over $250,000, and the film *Camelot* followed from this. He decided to go on a world cruise to celebrate his good fortune, but as was his wont, he drank too much, and died alone in his state room, aboard ship in the Port of Piraeus, of a massive heart attack. Just two years before he had written in his diary … *'I expect to make rather a good death. The essence of death is loneliness, and I have had plenty of practice at this.'*

In the late 1980s I found myself in Athens and remembering that White had been buried there in 1964, I went

to the Protestant Cemetery to see his grave and pay my respects. Standing in the scorching Greek wind, I read the simple inscription on his gravestone—*'T.H. White, 1906--1964, Author ... who, from a troubled heart, delighted others, loving and praising this life.'* Looking up from his grave, I could see the ruins of the Temple of Zeus and Hadrian's Arch; two monuments whose legends had fascinated White all his life. The words 'troubled heart' stirred some old, long dormant emotion in me and I remembered White as I had seen him in O'Meara's pub all those years ago; a young, strong man, crying over the death of a favourite dog.

That visit to his grave got me to thinking very seriously about him again, and I began to re-read several of his books, and inside a year I was planning a radio documentary on his life. And, through researching it, reading more about his life and talking to people who knew him, I came to love and understand the man I had seen crying in that Dublin pub, all those years ago. For Tim White had that deeply sensitive side to his nature that all truly great and good people have. A wonderful gentleness, sometimes mistaken by boors and idiots, for 'softness', for 'femininity'. Yet, in every truly strong man there is this touch of 'femininity'. In such gentleness is real strength.

Again, like most strong and sensitive people, Tim White was full of contradictions, full of inconsistencies. Loving fishing and shooting as he did, he was often criticised for his shooting activity whenever he proclaimed his hatred of war— his abhorrence of the destruction of life. Having such inconsistency pointed out to him seemed to matter not at all. Though, after a day spent shooting wild geese in Mayo, he made this entry in his diary ... *'Shot two young white-fronts*

this evening on Lough Carrowmore. Looking upon the noble corpses in the hard hail and scudding moonlight, I determined to shoot no more wild geese.' And he never did.

He could be equally sensitive to other aspects of nature. There was a bog in Meath, near Ballivor, where he often went to fly his falcons. On this bog there was a lovely grove of more than a hundred Douglas firs; mature trees, over a hundred years old, exquisitely beautiful and irreplaceable. Sold to a timber merchant, they were felled, and then left lying there through a hot summer. Of this White wrote in his diary: *'They were felled, like murdering seals ... All that hundred-year-old timber, first murdered, then through slovenliness made worthless.'*

I often think about the barman's unkind remark that long-ago day in Dublin about White just sitting out the war in Co Meath. Indeed, that was the perception many of the people I talked to had of Tim White; that he was a coward, afraid to fight, and not the conscientious objector he claimed to be. However, all the evidence I could find about this sensitive, gifted and extremely complex man pointed to the sincerity and honesty of his pacifist feelings. The main thing that must be stated in Tim White's defence is that he was sensitive and a true romantic. Then we can begin to appreciate his abhorrence of war, and begin to see him as a truly brave man; brave enough to go against the tide of public feeling and declare himself firmly 'against all war'. In a letter to a friend in England, justifying his pacifism, he stated he was acting in accordance with the 8th century Convention of Druim Ceat. 'I am a Bard and my person is inviolable.'

But in fact, Tim agonised a lot about the war. He suspected that this conflict in which he had refused to fight might well be the end of civilisation as we knew it, and he vacillated between the poles of involvement and non-involvement. You see, there was much of both Arthur and Launcelot and even Merlin in Tim White. He was obsessed by the Camelot/Arthur myth. He was also a man of enormous enthusiasms; his falconry, his hunting, his fishing. However, his over-riding passion was for his writing. His wild mood swings were dictated, almost entirely, by how well or how badly his writing was going.

Among those to whom I talked who knew White at that time was Vincent Evers. Vincent was then a young man himself; his family owned the farm adjoining that of the McDonaghs, where White was a paying guest. The two were close friends, and Vincent was certain that Tim was a 'very honest and genuine conscientious objector', despite what the locals thought. He also remembered the writer as being quite prodigal of his time in helping others; the McDonaghs on the farm; showing a neighbour how to divine water; research for the local Historical Society; and anyone who quite simply needed something done.

Indeed, it was almost as if this frenetic activity was some kind of refuge for him; a refuge from himself and from his intense loneliness. For instance, during that first summer at Doolistown in 1939, he worked extremely hard on his 'Arthur' books; yet while being also very involved with his hosts, the McDonaghs, he remained extremely lonely. About that time he wrote in his diary: *'Yesterday was my birthday. I felt, vaguely, that that ought to have had some sort of significance for somebody, but it hadn't. Not even for me ...'*

White had once written that Launcelot's character he understood perfectly; more fully than Arthur or Merlin. Arguably because Launcelot's character was really Tim's own. Intensely sensitive to all moral issues, probably slightly sadistic, and therefore consequently leaning towards gentleness to compensate. Like Launcelot he was superstitious, totemistic, fastidious, and monogamous. In the time-honoured tradition of Captain Ahab, Launcelot, John Cassian, Ethel Mannin and others, Tim was a true *isolato.* And, like most *isolatos,* he was self-questioning, self-doubting, driving himself to the verge of enormous depressions, but saved always by his diversity of interests, his passion to 'get things done'.

About the time I saw Tim White in 1944, winds of change were beginning to blow in his life. The tide of fate or chance that had brought him to live in Ireland was now turning and about to bear him in another direction. He was preoccupied with two unfinished books—*The Elephant and the Kangaroo* and *The Godstone and the Blackymor*—and felt he needed the stimulus of a change of domicile and the proximity of like minds to enable him to finish them. His friend, Ray Garnett, offered him a cottage in Yorkshire. He left Ireland in the autumn of 1945, never to return.

The Elephant and the Kangaroo, a novel set in Meath, was published, in an American edition in 1947. It caused great offence in Trim and Doolistown to the people with whom he had lived in such harmony for six years. What White had considered to be gentle humour was perceived as deeply offensive, despite the fact that White had lampooned himself in the book, describing himself as '… *a tall, middle-aged man with a straggling beard. He looked willing and fairly anxious,*

like one of the Sikhs at Queen Victoria's funeral, as if he was a good dog who was going to retrieve your walking stick.'

The novel also caused much anger among Irish-Americans, who condemned it for ridiculing both the Irish Republic and Catholic Ireland. *The Irish Echo* in New York was eloquent in its condemnation in May, 1947: '*We ask our readers to condemn* The Elephant and the Kangaroo *in no uncertain terms, and to regard it as just another typical English stab in the back which will only prove a boomerang.'*

Unfortunately, the offence it caused is still felt by the people of Trim and Doolistown; and for as long as some of those who knew Tim White while he lived there are still alive, that feeling is unlikely to change. Not for the first time, and not for the last, the 'English' had misjudged us and 'we' had misunderstood them. White was absolutely desolate; and helpless to redress whatever wrong he had unwittingly done, he lost touch with the McDonagh family after that. So, on that sad note ended Tim White's Irish idyll, during which I had the good fortune to encounter him, however briefly, in a pub on the Dublin quays.

A Shack at Sag Harbour

John Steinbeck

When I worked in New York in the Sixties, I found little to attract me in its sunless streets. So, come Friday evening I was on the road, driving for two or three hours, as the humour took me or as the season and weather dictated. Finding some small country inn, booking for Friday, Saturday and Sunday nights, and exploring the place and its hinterland on Saturday and Sunday. Then, leaving early Monday, I could be back in the city by mid-morning, in time for the noon management meeting; fortified against the cockamamie ruck and reel of another week of 'peeling potatoes' in The Big Apple.

For that is how I considered my work in public relations; work about as important, challenging and satisfying as what Cyril Connolly had called 'peeling potatoes' in *The Unquiet Grave,* a book that had literally changed my life. Yet while I felt that my time spent as a potatoe peeler was coming to its term, I had not yet quite summoned up courage enough to leave the lucrative business of public relations and strike out into the uncharted and unchartable territory that was 'writing for a living'.

Working in this random fashion, my weekends away from New York helped me focus on the decision I knew I must make, sooner or later. I also discovered some lovely places;

places to which I returned again and again, for my soul and my sanity's sake. And one such place was the little seaside village of Sag Harbour, a few hours' drive from New York, on Long Island not far from the town of Southampton. It had a small harbour and some great seafood restaurants. Some of these took the produce—the lobster, the prawns, the white fish—directly from the boats when they came in. You could be sure that what you were served that evening had been landed, at worst that morning, at best that afternoon. It had expensive places to stay, but it also had reasonably priced accommodation, if one took the trouble to look around. I found such a place, on the quayside, with accommodation above the bar and restaurant where I got the best shellfish I've ever eaten, and had a great sea-view from my bedroom. I stayed there regularly.

The little bar was tucked away at one end of the restaurant, with just enough accommodation for those waiting to dine. The dining area was wonderfully appointed. Walls of panelled oak; low oak beams framing cream-coloured ceiling panels on which were depicted very beautifully executed maritime scenes. And every table was placed in its own private alcove, the oak partitions rising to a height of four-and-a-half feet. So that when the diners were seated, they were afforded great privacy. Dining there, I was always reminded of the old oak confession-boxes in the Catholic churches of my youth. Ever since those childhood days I have equated old, polished oak with comfort, privacy, safety and confidentiality.

The lighting in the restaurant was soft, discreet, coming from converted storm-lanterns mounted on oak wall brackets. The harmonious effect of all this was, whether by accident or design, truly conducive to enjoying one's food. The ambience

could so easily have been reverential, or just downright oppressive. Miraculously it stopped short of that and was simply in good taste, relaxing, affording each table its privacy. If you dined alone, as I did, and enjoyed your own company, as I did, you could have that. If you had taken somebody special to dinner and desired a *tête-à-tête,* you could have that also. Sometimes, as if to prove that all norms, all rules, are there to be broken, there was an over-spill from one booth to another.

Dining alone one Saturday evening, I had just finished a lengthy discussion with the waiter, a Wexfordman from Fethard-on-Sea, when I felt a very gentle touch on my elbow. I turned to find one of the diners from the next-door 'confessional' leaning toward me. I instantly recognised the smiling face as that of the novelist John Steinbeck. This identification was not difficult. The same friendly face had been smiling at me from New York bookshops, and from the pages of newspapers and magazines, almost every day for the past year, 1962, the year in which he had won the Nobel Prize for Literature and published the book that had topped all the best-seller lists in America—*Travels With Charley.*

'Sorry to cut in, but your Irish accent caught my ear.' The voice was deep, strong, a touch of gravel, yet strangely gentle; like pebbles, abraded by the sea, knocking together on the sandy bottom of some rock pool.

And that started it. I was invited, when I had finished my main course, to join Steinbeck for coffee at his table. We talked about Ireland; about my being Irish; about his being Irish, in the sense that he had Irish grandparents. On the maternal side his grandmother had come from Cork; on the paternal side his grandfather had come from Northern Ireland. John was in full

spate now, and when he talked about Ireland nothing could stop the torrent. We talked about Joyce and O'Casey, and at one point in our conversation I mentioned that I had, as a boy of nine or ten, seen T.H. White in a Dublin pub.

'Two questions, two questions!' Steinbeck laughed. 'I know they start 'em young in Ireland but what's a kid of twelve doing in a Dublin pub? And seriously, tell me about T.H. White?'

'Well, he was a conscientious objector living in Ireland during the War,' I explained.

'He sure put that time to good use. Wrote *The Once and Future King* books in Ireland didn't he?'

'Most of them,' I said, adding, 'I wrote some articles about him a few years later. And would like to make a radio programme sometime about him.'

'You read Malory then ... the *Morte d'Arthur*?'

'Yes, a very old edition, when I was a boy.'

'Probably the old Dent edition of Caxton. Back about 1893. Hasn't been anything later.'

'I think what I read as a boy,' I said, 'was an abridged version called *The Boy's King Arthur*.'

'That's right,' Steinbeck said, 'I remember it now. Came out in 1900.'

I sensed immediately that we had hit on a subject of great interest to us both. So not surprisingly, six coffees later and just after midnight, we left the restaurant. He had invited me to come up to his 'shack on the point' for a night-cap, adding that he wanted to 'show me something about Arthur'. He would be

glad of a little company. His wife, Elaine, was away for the week-end.

Now when an American writer who had written as many best-sellers as Steinbeck had, and who has won the Pulitzer Prize and Nobel Prize, invites you to 'his shack', you assume he is being modest. While you may not expect a colonnaded colonial mansion, you do expect something larger, and more imposing than the holiday cottage I found myself approaching after a mile-long walk from the village.

The house and the surrounding garden were clearly visible in the light of a full moon; beyond the end of the garden the sea was a rippling sheet of silver, stretching away to the horizon. The dwelling was indeed a shack. Originally a typical summer cottage, not insulated, utterly flimsy in its construction, it had grown, by additions, from owner to owner over the years.

While he busied himself getting us drinks, Steinbeck explained that what he had really liked about the place when he bought it a few years before was 'its possibilities'. The thing he missed most about living in New York City had been 'there was no sea!' And he loved the sea. So this ramshackle cottage, with its huge garden sloping right down to the water, was ideal. 'I didn't mind what condition it was in, or how badly constructed. It could be 'imagined' the way I wanted it,' he said. And the way he said that left no doubt. This was a man to whom the reality of things had nothing to do with how they looked to the eye, sounded to the ear, felt to the touch. The only 'reality' for him was how he could 'imagine' them. This was a man who had long-since learned to live in the wonderful kingdom of memory and imagination.

After he brought our drinks, he took me to a window that looked out across the garden. He pointed to the outline of a small, oddly shaped building on a little bluff, silhouetted in the moonlight against the great silver spread of the ocean. It was a small 'workroom' he had built himself. Sometimes he wrote here in the house, but almost every day he went down to the little hut over the sea and worked there for several hours. We stood by the window, looking out on the moonlit garden and the silver sea beyond. For a few minutes his thoughts were very far away, and when he came back from that far country, he said with a lot of emotion in the gravelly voice: 'The house didn't really matter, it was the place, the location, and the garden. It all reminded me so much of Pacific Grove in that great, great time before Ed Ricketts died.'

We drank a Crested Ten whiskey, his 'special' he called it; sent him by John Huston from Ireland a few months before. I was surprised to find that, like myself, he drank it neat—no mixer, no ice. 'With a whiskey as pure as that,' he said, 'be criminal to mix anything. Mixers and ice are for some of the rough rye I drink.' Taking a drink now—anywhere, with anyone—always reminded him of Ed Ricketts. He said the older he got the more he missed Ed. Ed had been the very best friend he'd ever had. A mischievous, yet sad look came into Steinbeck's face, 'Ed and I did things, had adventures, got into scrapes. Some things I never wrote about. Never will now.'

But there was, of course, much of Ed Ricketts that he had written about. Much of Ed Ricketts that was also in himself. Ed's mind, like Steinbeck's own, had no horizons. They both had this immense interest in everything, this unbounded enthusiasm.

'Ed had just a few pet hates,' he said, 'and principal among them was his hatred of old age.'

I could see quite clearly that John Steinbeck, in his early sixties then, was beginning to share some of his dead friend's antipathy toward the inexorable march of the years. Though it is only now, thirty years later and in my mid-sixties myself, that I fully appreciate how the onset of old-age can be a cause of anxiety, if not downright fear.

He emptied his glass then and taking the bottle from the tray he had brought us, motioned me to follow him.

'Come on. Let's go outside. Want to show you something special in the garden. Wasn't it Yeats who said that lovely, true thing about seeing the countryside better by moonlight?

To my shame I couldn't remember anymore specifically than he did what Yeats had said. But Steinbeck didn't notice. In the garden everything was drenched in moonlight; a clear, pellucid light that reached into the little hidden corners, making plants, and shrubs and trees stand out in detail. Beyond the garden and the pier at its end, the sea was a sheet of burnished silver, stretching away to lose itself in a moon-grey mist, though the horizon had been clearly visible just minutes before. The sea made a sucking sound as it lapped the shoreline at the end of the garden; like a hundred mouths sucking in harmony. And somewhere along the cliff, a colony of raucous gulls, restive, unable to settle for the night, emitted little tentative calls, punctuating, accentuating the silence.

Steinbeck stopped beside a bush growing in a sheltered corner of the garden. Its leaves glistened in the moonlight.

'That,' he said, making a little sweeping gesture with the whiskey bottle, 'is a Glastonbury Thorn. Took it all the way

from England a few years back. From Somerset. King Arthur country. Just a cutting then. But it rooted alright. Flowers at Christmas. Looked great in the snow last year.'

Then he was gone off across the lawn toward the 'workroom' he had earlier pointed out to me from the window. I followed him. The building, on a bluff directly above the sea, resembled a miniature lighthouse. It was six-sided, and as I came closer I was struck by how many windows it had. The door was unlocked, and opening it he invited me inside. Moonlight streamed through the uncurtained windows. The single room was really small; just big enough for a very old desk and a single chair, and various cubby-holes in which he kept his books and manuscripts. He stood in a shaft of moonlight for a minute or two, looking round the tiny tower, and said: 'I've done a lot of good work here. And there's a lot more to be done.' Then gently closing the door we left, and as we walked down to the sea, he told me he had called his little work-house *Joyous Garde,* after the castle to which Launcelot took Guinevere in the Arthurian legend.

At the little pier his boat was tied up, the lovely line of her clearly visible in the moonlight. It was a twenty-foot long, clinker-built sea skiff, with an eight-feet beam, and an extraordinary looking convertible top, just like a car. As we regarded it, he proudly told me it had a hundred-horsepower Grey marine engine, powerful enough to carry him across the Atlantic, had he space to store the gasoline. And he added a little sadly, if he had the will to go. A lot of that 'will to go' had been eroded by the death of Ed Ricketts, and though he loved Sag Harbour, it was like all places, things, or people that are second choices. It was a substitution, and he loved it only in

so far as it reminded him of that other place on the West Coast, where he had had such wonderful times with Ed.

After that we strolled back across the lawn. We sipped whiskey as we walked, and he dangled the by now half-empty bottle, the bright moonlight catching the sheen of the golden liquid. Outside *Joyous Garde* he stopped. With the whiskey bottle he motioned me to follow him.

'Come on inside again. Something I forgot to show you.'

With just the moon shining in to light the place, he knew exactly where to find a bulky folder, with the words 'ARTHUR - MALLORY' written in large capitals on the cover. He placed it on the desk and held his hand on top of it.

'T.H. White territory,' he said with a sigh.

Then, looking out the window, he was silent for what seemed a long time. When he eventually spoke, his voice was soft, almost reverential, as if he were speaking about something sacred. Which, in fact, he was. He explained to me about his interest, his love, his near obsession with Arthur.

Since college, he had been in love with the whole Arthurian legend; Malory had been one of the first authors to really take hold of his imagination. The legends of King Arthur, particularly as told by Malory, had fascinated him. All through his writing life he had wanted to rewrite Thomas Malory's *Morte d'Arthur* in modern English; in simple, readable prose, without adding or taking away anything. Just translate the obsolete words to modern ones, straighten out some of the more involved sentences. A few years before I met him, he had gone with his wife Elaine on an extended trip to Europe, specifically to track down some Malory manuscripts in Florence and Rome. Encouraged and greatly stimulated by

what he found he had extended his European trip to take in England. He wanted to be close to the land that had nourished Malory.

All his life had, in a sense, been aimed at just one book, the 'big' book, the story of Arthur and Camelot. And here he was, in his early sixties, and he had not even started yet. 'Maybe I'm like Launcelot, who, because of his imperfection, never got to see the Holy Grail,' he said with some sadness. 'Been working and planning toward this for over forty years, but when it comes to actually writing it, it scares the hell out of me.'

He went on explain how like Launcelot the writer was. Once the actual words went down on paper, the writer was alone and committed. And that was the isolated time, the lonely time. Like Launcelot, the writer, he thought, was also doomed to failure, for the Grail was not a cup. Not anything tactile. It was only a promise that like a carrot on a stick, skipped ahead, drawing you on ...

He had spent the better part of 1959 living and writing in Somerset, in a cottage found for them by Robert Bolt, the playwright. The Glastonbury thorn he had just shown me in the garden had been given him by Bolt. He had written the first few chapters of his 'Arthur/Malory book' that spring and summer in Somerset and with great enthusiasm had mailed them off to his publishers, Pat Covici and Elizabeth Otis.

The reply he received was not at all what he thought it would be. It seems they expected a rollicking, romantic adventure story, similar to White's *The Sword in the Stone*. Something that might win a big audience. Steinbeck's faithful translation of Malory had failed to catch any of the poetry of the original. Sadly he closed up his cottage in Somerset and

returned, disillusioned and depressed, to Sag Harbour. He abandoned the whole Malory project and suffered the first of what he referred to as his 'little episodes'; a series of minor strokes that temporarily left him with uncertain speech and loss of use in his fingers.

He was still going through this series of 'episodes' when I met him. But fighter that he was, managing to write through all his miseries; producing some of his most popular work, like *Travels With Charley*. The Sixties were a difficult time for John Steinbeck in spite of, or perhaps—in part at least—because of winning the Nobel Prize. He was, all his life, a simple man. Success, fame, awards, never changed that. He had always admired, above all else, three particular qualities in people—simplicity, clarity and generosity, and it was these qualities he cultivated most in himself.

Simplicity was a very basic thing with him. He joked that, like Mark Twain, he thought it best to always avoid occasions requiring a change of clothes. Clarity was the very essence of his writing; he had no time for the pretentious of literary modernism. Like Henry Miller, generosity was a veritable trademark with him. He was loyal to old friends; ever-willing to give of his time and his money in times of emotional or financial crisis.

It was a privileged evening—a brief and singular encounter—and I was sorry it had to end. But I appreciated he was a man in failing health. He joked about how if his wife Elaine had been there, she would have put a stop to our gallop of conversation. Sensitive to his tiredness, I knew it was time to go and reluctantly said good-bye.

As the Sixties drew to a close I was less and less in North America, but travelling a lot in Central America and Europe. Just before Christmas 1968, I was in Lisbon when I heard of John Steinbeck's death on the radio. He had been suffering from emphysema and hardening of the arteries for some time, and it was too late for surgery. He died of heart failure, not in hospital, where he had spent a lot of time over the last four or five years of his life, but happily in his apartment on East 72nd Street in New York City. He was sixty-six years old.

In 1970, two years after his death, I found myself in Athens for a few days. I went out to the Protestant Cemetery to visit T.H. White's grave, where I remembered Malory and Arthur, Launcelot and the Holy Grail, and the two writers who were so in love with the legend.

Then, many years after Steinbeck's death, when I had settled back in Ireland I wrote a piece about him for *The Irish Times*. On the afternoon of the day it was published I received a phone call from a Dublin doctor. He and I had never met, but he wanted me to know that he had read my piece and liked it. He had worked as a young doctor in Southampton Hospital, not far from Sag Harbour, in the Sixties, and had been on the team that ministered to John Steinbeck during several of his 'little episodes'. The same period when I had my brief encounter with Steinbeck at Sag Harbour.

Though I could not possibly have foreseen it in 1962, there was to be in the years ahead a further parallel with Steinbeck. In 1986 I suffered a major heart attack and had emergency surgery; a quadruple by-pass saving my life. For the next eight years I lived a normal life, until January 1994, when I suffered the first of a succession of seven heart attacks, which

necessitated a heart transplant in September of that year. Unlike Steinbeck however, I recovered.

Often too, I think of him as he started to write that mammoth novel *East of Eden*, and the letter he wrote to Pat Covici, his publisher, bemoaning his innate clumsiness and aching inability to write as well as he would wish. But also rising above all those self-doubts by stating that sometimes when he sat down to write, he felt he held a fire in his hands and could 'spread the page with shining'. And that, surely, is what every writer who is serious about the craft attempts to do, every time he or she sits down to write. The possibility of filling that page with shining is the carrot that, like the Holy Grail with Launcelot, dangles and dances ahead of us, making it, not just possible to go on, but *impossible* not to go on.

My brief encounter with John Steinbeck was the initial stimulus, the nudge, I needed to make me think seriously of getting out of the insidious business of public relations which, for too long now, had been seducing me with its siren song of money and perks and much-vaunted, so-called sophistication. After that weekend at Sag Harbour, I began questioning a lot of the values I had unthinkingly accepted heretofore.

However, human nature being what it is, and courage a rare commodity, it took another few months and a brief encounter with a second catalyst, to finally effect the death of a potatoe peeler and my reincarnation as a writer. Just another manifestation of those brief encounters that can reshape our lives.

The Reluctant Politician

Dr Noel Browne

A week after Dr Noel Browne's death in 1997, I rang his widow, Phyllis, at their home in Connemara. I had been hospitalised when he died and could not attend the burial. I ended that call by asking Phyllis to please keep in touch, to let me know where she finally settled.

Her reply surprised me. 'I'll probably stay here in Connemara,' she said bravely; adding sadly, 'I wouldn't like to leave Noel now.' But her reply was in character, made a lot of sense, when I considered what Noel had written in the Preface to his autobiography—*Against The Tide*—in 1986. 'In the story of a life, of which over fifty years has been lived together, does not my wife become the joint author? In a just world, beneath its title, this book should have subscribed two names, Noel and Phyllis Browne.'

I should not have been surprised, really, that in Noel's death he and Phyllis were not divided. From the moment they met at a Trinity Boat Club dance in the late 1930s, the two had been inseparable. Even Noel's years of incarceration with the dreaded tuberculosis that had ravaged his family did not succeed in keeping them apart. From 1937 until the day he died they had shared everything; had been husband and wife, boon companions, helpmates, co-writers, willing conspirators for

social progress, avowed arch-enemies of humbug, hypocrisy, cant and mediocrity. Phyllis and Noel had, very early in their relationship, decided that the proper, indeed the only path for them to follow was the difficult one of being social revolutionaries.

I first met Noel and his wife Phyllis in the spring of 1993, when I was planning to edit a book about Connemara. The documentary-style book was to be comprised of edited interviews with local people right across the socio-economic spectrum; from Lord Killanin to the fisherman-farmer who eked out a living in the lunar landscape of Lettermore and the islands. A handful of the interviews were to be with people who, though not natives, had settled in the area and become part of it. People like Noel and Phyllis who had loved the place, and contributed much to its development; had visited it and spent long summer vacations there and eventually, when it came to retirement, had moved to live there.

I remember well driving out to Ballinahoun for that first interview. I had never been in that part of Connemara before, never further West than Spiddal and though they had given me very explicit directions on the telephone as to how to get there, I lost my bearings several times. A light spring rain was falling, and amid the unrelieved grey rocks of what seemed to me a pre-historic landscape, one endlessly undulating, tortuously winding little side-road looked much the same as another. Eventually after much stopping and starting and asking for directions, I came down the boreen to where their house stood just a stone's throw from the sea. On first seeing it in that spring rain, the eaves of the thatch dripping wet, the wild-flowers coming into bloom in the little front garden, I was surprised in the same way as when I first saw John Steinbeck's

house on the bluff above the sea at Sag Harbour. I expected something bigger. This man had been a Government minister, a psychiatrist; I had thought that in his retirement he would have built a modern house. But no; here he was in an old thatched cottage, whose only concession to modernity was running water and electricity.

I felt that, in the evening of a life given entirely to working for others, a life dedicated to the pursuit of acquiring some kind of equity for the socially deprived, this frail, seventy-eight-year-old would have been enjoying more luxury in his retirement. But that feeling just showed how little I knew of the man. Luxury was something Noel knew nothing of, cared nothing for. There was in him a great predilection for the spartan, the austere, the eremitic. All of his working life, both as a medic and as a politician, he had eschewed anything that bordered on the ostentatious. Words like sophistication did not belong in his vocabulary.

Upon entering the little house in Ballinahoun on that first occasion, I was struck by the similarity to the house in which I had been born and in which I had grown up, nearly sixty years before, in Co Waterford. The only difference at Ballinahoun being the electricity and running water. The living room was heated by an open turf fire; the whole room redolent of the pungent smell of turf smoke. And from the little kitchen, visible from where we sat, came the appetising aroma of home-made cakes, as Phyllis prepared a tray laden with the fruits of her morning's baking. The smell of home-baking was another reminder of my childhood home in Waterford, all those years ago, and I told Noel so.

From his enthusiastic reaction I learned a lot about the man. He told me how delighted he was to find that we—he and I—had the common denominator of having been born in the same place, Waterford. And there was, he said, the 'double-connection' of my having spent my youth in the same kind of house in which he and Phyllis were now spending their last years. It was wonderful to find that this man who had attained such stature in public life—achieved so much, become both famous and infamous, depending on your particular allegiance—was still in his late seventies so sensitive to such tremendous trifles.

He then reminded me, though I did not need reminding, for I remembered it well, of how, three years before he had written me to say how much he had enjoyed a drama-documentary about Saint Bernard, which I had written and presented. In that letter, Noel had agreed with my presenting Bernard as 'the first great European, the first great 'modern' diplomat'.

A few days after I'd received that letter, we talked on the phone. Noel again mentioned the St Bernard documentary, and told me how fascinated he was by the whole concept of the Cistercian way of life. I asked him what appealed to him most about it. I was sure he would answer that it was the silence, but he did not. Without doubt, he said, it was the utter simplicity, the spartan quality of it, the total eschewing of any trace of pomp or show in its liturgy; the living so faithfully to the concept of *labore et orare*. I remember joking with him at the time; saying that I felt he would have made a wonderful Cistercian monk. He responded in a similarly jocular way, saying that he felt the kind of life he had in Connemara was so close to the Cistercian ethic as made no difference. It was the only time I came close to discussing anything even bordering

on the religious with Noel. Like myself, I felt he was a very religious man without a formal religion, and any such discussion would be totally non-productive. He was a man who, more than anyone I have met with the exception of the Cistercian Thomas Merton, really knew who he was. Indeed like Merton, Noel told me he believed that, unfortunately, just because they knew their own names, many people didn't necessarily know who they were.

And sitting there by the peat fire in Ballinahoun, he reminded me of something else he had said in that letter. That listening to my voice on radio, in various documentaries and 'Sunday Miscellany' talks, he had marvelled at how like his own voice it was. 'It was like listening to myself,' he said, 'it had the same *timbre* as my own.'

I was both flattered and ever so slightly embarrassed by such a candid and sincere comparison, but was spared having to find a reply by Phyllis coming from her kitchen with the tea tray. Over tea we sat and talked, not about politics, but about radio. About how great a medium it was; how personal, how intimate, compared to television. Phyllis and Noel loved radio, and were regular listeners to 'Sunday Miscellany', a programme to which I had been contributing talks for several years. Many of these talks had been evocative, nostalgic pieces about my own Waterford childhood. Pieces in which, Noel said, he had found that shared experience.

And Noel and Phyllis had found their own connection in Connemara, many years before when he was Minister for Health, when they went West with their family for weekends and summer vacations. He laughed, amused now, as he

remembered the extraordinary way in which that had all come about, when he was the newly appointed Minister for Health.

Initially, the most harrowing part of his job as Minister was the terror of Question Time in the Dáil chamber. In deference to his inexperience deputies of all parties showed commendable restraint in their questions. With the exception of, to quote Noel, 'the incorrigible Sean McEntee', his predecessor as Minister for Health. Knowing well that, because of Noel's English education, he would have no Irish, McEntee has arranged that Gerald Bartley, a Fianna Fáil TD from Connemara, should submit a question in Irish. However, resourceful as he was, Noel coped extremely well. He had a fluent Gaelic speaker in his Department translate the question into English, and then translate Noel's answer into Irish. Noel was then tutored in the phonetic version of the reply. On the day he surprised the assembled House into silence. But he had learned a lesson and immediately set about learning Irish. The first step on that road was Connemara, and a great, great love affair with a place, its people and its culture had begun.

At that first meeting, or indeed, at either of our subsequent meetings, Noel and I never talked 'politics' *per se*. Indeed, I think in some strange, inexplicable way he envied me my self-declared position as 'an apolitical animal'. He had, he admitted, become a politician very reluctantly. At a time when he had committed himself to working toward some form of socialised medicine, he realised that worthwhile results could only be achieved by working from the inside out, not from the outside in. Sean McBride's Clann na Poblachta Party offered him his chance to become Minister for Health on his first day in Dáil Eireann.

In that initial conversation, and in subsequent conversations with Noel, I always sensed, in this kindred spirit, a great unspoken desire to be free. Free that is of all political, or indeed any other, allegiance. Free to practice medicine; free to read; free to write. For if ever there was a writer *manqué* it was Noel Browne. His erudition, his questing mind, his sensitivity, his incredibly boundless compassion, his love of language, all drew him to writing.

Noel also had this fantastic in-built feeling for recognising what he termed 'egalitarian mediocrity' a mile off, and the oh-so-commendable strength of character to avoid all such involvement as one would avoid bubonic plague. What's more, he had a habit in conversation that reminded me of a toy I remember receiving with absolute joy one Christmas long ago. It was a small mechanical fox with a special coil-spring feature which—after it had rushed headlong toward the edge of the table—always ensured that it miraculously pulled back and went away in the opposite direction. And, like that little mechanical fox of my childhood, Noel Browne would repeatedly stop short and pull back from discussing anything he considered a waste of good time.

I still, very often, take down his magnificent autobiography *Against the Tide*. It is one of my favourite 'comfort' books. In it I can find so many things that confirm my worst fears about many of our sacred institutions, and reaffirm my unshakeable belief in the sanctity of the incorruptible loners; the independent men of vision, the men of integrity, the men who, like Noel, sacrificed self, and personal happiness, and comfort in an uncompromising assault on all the bastions of corrupt power, elitism, and double-dealing.

At the end of that visit to Ballinahoun, satiated with Phyllis's tea and home-baked scones and cakes, Noel and I walked a little way along the sea shore behind the cottage. I did not know it then, but we walked past the very spot where, a few years later, they were to dig his grave in the sandy soil of the foreshore. When we returned to my car dusk was already blurring the stone walls and little fields of the grey landscape. A little distance from us, on a bluff outside a neighbour's house, stood three cars and a tractor. And near that, outside another house, were two cars and another tractor; all silhouetted against a murky, grey-gold Connemara sunset. Noel sighed as with a sweep of his arm he indicated this scene.

'What a waste', he said sadly. 'Grand to see the cars, they're needed in a remote spot like this. But a tractor each! For what? A few patches of stony soil between the boulders. One tractor would service ten of these small-holdings. But they must keep up with the Joneses!'

Over the next year I suffered a series of severe heart attacks and saw nothing of Noel and Phyllis, though we did exchange occasional letters. The next time we met was quite by accident. It was in the autumn of 1995, and I was in Galway for the day. Before getting my late afternoon train back to Dublin I went into the Great Southern Hotel in Eyre Square for tea. Phyllis and Noel were taking tea in the lounge, and I joined them. I was shocked at how much he had deteriorated in the two years since our last meeting. His movements were slower, his speech was slower, and his voice was no more than a loud whisper. He had always been slim, but that afternoon he looked positively emaciated, having lost a considerable amount of weight.

As we talked, however, I quickly realised that he had lost nothing of his interest in what was happening in the world. Neither had he lost any of his quick, acerbic wit. But there was a certain sadness about him; something impossible to define, or describe; as if a light had been extinguished and could never be relit. He looked as dapper as ever, dressed in his dark slacks and *bainin* jacket, with his navy-blue 'sailor' cap at the usual jaunty angle, and the gold tie-pin holding the carefully ruffled cravat.

Phyllis and he and I talked for nearly an hour. Mostly about my recent successful heart transplant. Noel, as usual, was always particularly interested in anything medical. In his estimation Maurice Neligan, who had performed my transplant surgery, was a 'genius'. When Noel excused himself, to go out to the toilet, Phyllis took the opportunity to quickly quiz me about what kind of symptoms I'd had in the period when I'd suffered the heart attacks. She confided she was very worried about Noel's health, especially his heart, as he'd been showing signs of breathlessness. I did my best to help in the limited time we had before Noel came back. Then it was time to leave for my train.

After that meeting I was quite concerned about Noel's health and wrote regularly. At first he replied to my letters and cards. The tone was always polite and friendly, but the notes got shorter and shorter with each passing month, with, invariably, a word or two of apology for such brevity. The writing, while still easily deciphered, became somewhat spidery. There was always a promise to write a longer letter soon. Then the replies began to be written by Phyllis. Noel's health was in a rapid decline; he was too weak to write anymore. So Phyllis wrote for both of them. I thought of

making a trip to Connemara to see him, but a deterioration in my own health prevented that.

My third, and last meeting with Noel was in 1997, just a few weeks before he died. Again, as in the Great Southern in Galway, we met quite by chance. This time in Dublin, outside the Lincoln Place entrance to Trinity College. It was a chilly, showery day and I was making my way from Westland Row toward the National Library, as quickly as my two crutches would permit. Ahead of me I noticed a man battling against the strong wind. He was thin and frail-looking. There was something familiar about him. Then, as I came slowly up behind him, I saw the navy-blue sailor's hat, and realised it was Noel. We had a kerb-side reunion, before walking on together to Kildare Street. I was going to the National Library, he to Dáil Eireann. We had no time to have a coffee or a tea; but then, that was never in the least important to either of us. We stood for a short while at the gates of Leinster House. He was frail and tired, and wondered how he was going to get through an afternoon of 'traipsing round Leinster House with a film director', vetting locations for the forthcoming filming of his autobiography *Against the Tide*. He made some joke about the irony of coming back, after all the years, to the place which had been the greatest battleground in his life. 'Some won, some lost,' he said as we parted. I never saw him again.

I was in hospital myself, some weeks later, when news of his death reached me. It was not possible for me to attend the funeral. But I was certainly there in spirit, for from our first meeting I knew that he and I had a great affinity. On his own admission he had been a reluctant politician. In a better world, a more utopian world, a world less in need of his caring,

crusading spirit, he might well have become an outstanding writer, an academic, a philosopher, or a Cistercian monk.

Noel was often called naïve and idealistic, usually by philistines and cynics, who deployed the words as if they were obscene. And he was, of course, gloriously unashamedly naïve, impossibly idealistic, infuriatingly radical. He was a man who, to the very end, suffered much for the integrity that burned in him like an unquenchable flame. Like a brave, ostensibly foolhardy swimmer, he had always gone way out past where it was safe to go, without life-belt or life-line. For there—out past where others dared to go—was where he knew the magical things happened, and the impossible was so often achieved. But he also knew that one could die 'out there'; one could sink, vanish without trace. That he did not is a tribute to that innate instinct of his for survival, like the little mechanical fox I had as a boy. It was for all this I loved the man so much, and wish now that I had met him earlier in my life. Noel had so many gifts, and he had the courage of them all. Which is what made life so difficult for himself and those whose lives touched his. He was a man in whose personal dictionary the word 'compromise' did not exist. Indeed, I might well have titled this essay 'No Compromise'.

Noel Browne's life was one long, sustained, incredibly courageous and blindingly beautiful insult to mediocrity; the insult Jeanette Winterson describes so trenchantly in her essay on Virginia Woolf—'the insult of the saint to pragmatists everywhere'. I think of him every day. He remains a salutary reminder to me to continue to blow—as he had done—what Norman Mailer once described as 'the small trumpet of our defiance'.

The World's Most Expensive Breakfast

Robert Frost

During the short reign of John Fitzgerald Kennedy as President of the United States of America—that ostensibly halcyon time when all too briefly Camelot seemed to have materialised again—his wife, Jackie, espoused many worthwhile charitable causes. This, in a commendable eagerness to achieve something worthwhile in her term as First Lady at the White House.

To ensure the success of these endeavours she enlisted the support of many well-known people—poets, musicians, painters, composers and movie stars. The charities were always so genuine, their need so pressing, that she became a willing mendicant on their behalf. She lent her support, her name, and very often her presence, to a variety of fund-raising occasions—high-society soirées, luncheons, dinners, sports events and once, a breakfast in Rockefeller Center, New York City, which I had the good fortune to attend.

There, quite early one warm spring morning in 1962, she introduced the poet, Robert Frost, to an understandably respectful, albeit slightly bemused, audience. Few of those attending were accustomed to poetry at any time, and none of them to poetry with breakfast; even a breakfast of fresh orange juice, champagne, coffee and flapjacks with maple syrup.

It was the world's most expensive breakfast at a thousand dollars a ticket. You see, Jackie Kennedy had to help raise some really big money quickly, for the victims of a flood disaster in the Midwestern States. So she sold a single ticket, at 1,000 dollars, to each of the 150 top corporations in New York City; mostly located along Fifth Avenue and on Wall Street. Robert Frost, beloved octogenarian poet, close friend of the Kennedys, was a popular figure, and the cause a worthy one, so a corporate cheque was no problem. And it was left to each company to nominate an individual to represent it at the breakfast and poetry reading.

In most of the offices concerned there was intense competition for this nomination; lobbying, toadying, back-slapping, back-stabbing. Not so in the outfit where I worked. From the outset I was leading contender. My Senior Vice-President was second-generation Irish and like most Irish-Americans, though tough as they come in business, ridiculously sentimental when it came to all things Irish. To him, the Irish were all poets, ergo all American poets *must* have Irish blood. (Though in fact, Robert Frost did not.) So my boss gave me the ticket, saying, 'You will appreciate the poetry! Most of the people in this office wouldn't know the difference between a poem and an inter-departmental memo. They'd just go along to guzzle champagne and gape at Jackie Kennedy.' A pragmatic, if somewhat uncharitable assessment of the talent in the room, I thought, accepting the invitation with alacrity.

My most abiding memory of that unique breakfast is of a chiaroscuro of incongruities and contrasts. The old poet, with snow-white hair and weathered face, shapeless in baggy tweeds, and the young, svelte First Lady, resplendent in

expensive *décolletage*. Mrs Kennedy effected the introduction in a formal, well-modulated soprano.

'Ladies and gentlemen. My thanks to your various corporations for their subscriptions to this worthwhile cause. And to you, personally, for coming here so early to breakfast with us, and listen to Robert Frost read his poetry. I would ask you to refrain from applauding each separate poem until the reading has finished. That will make it easier for Mr Frost to concentrate, and we will be able to get you to work on time! Thank you!'

Frost began reading, his drowsy 'barreltone' caressing the rich, colloquial rhythms. His voice gruff, almost hoarse, like the trundling sound of the wheels of a farm cart on a rutted country road. He was so relaxed, so informal, so utterly oblivious of his surroundings, that he might have been talking to friends round his own New Hampshire fireside. His first poem began:

> *I walked down alone, Sunday after church*
> *To the place where John had been cutting trees*

From those opening words he had his audience in thrall; in spirit we rose, as one, and walked down to where John had done his cutting .

Just beyond us on Fifth Avenue, the early-morning traffic flowed. Round us the skyscrapers towered, their upper windows catching the first of the warm, spring sunshine, the acres of glass and pre-cast concrete convecting the heat already into the sunless canyons of the morning city. So far removed from the place where 'John had been cutting trees'. And Frost's audience, mostly mohair-suited males, but with a

sprinkling of silk-and-linen clad Jackie Kennedy lookalikes—all clutching their monogrammed, real-leather document cases—totally succumbed to the rustic charm of the eighty-eight-year-old master word-painter from Sugar Hill, Franconia, New Hampshire. Gradually, incredibly, the softly monotonous mesmeric voice seemed to drown out the hum of the traffic, and spirit his sophisticated listeners away from Manhattan, to a land of 'new-mown hay,' 'yelping dogs,' 'pathless woods', 'tufts of flowers' and 'cows in appletime'.

To open with those lines was a touch of genius, whether conscious or unconscious. The casualness of it—the image of the farmer-poet wandering in his fields, the word-pictures of the bucolic countryside—acted like some benign drug. The last of the breakfast champagne was quickly scoffed, the last of the coffee drained; flapjacks were left half-eaten, maple syrup dripping onto the tablecloths, as this unlikely audience truly settled in to listen to this old man meander through his poems.

I had never heard Frost read before and never did again. For all I knew he could have begun all his readings with that same poem, cleverly calculated to engage his listeners' attention, lead them on into that magic kingdom of the poet's imagination. However, I got the impression that he did it all on an *ad hoc* basis, with no formal presentation planned, no stage management, as if he always knew which poem of his with which to begin to engage the attention of different audiences. He seemed to me a man who had mastered, long ago, the art of instantly finding a common denominator with any audience, which is the mark of the truly great communicator. The poems that followed were half-read from a few dog-eared, well-worn books, drawn out of the capacious pockets of his baggy suit. They were more than half-remembered from countless public

readings. Always prefaced by a little information about himself and his contemporaries; little humorous, or whimsical anecdotes; never any attempt to explain the poem. The poem stood on its own legs in the reading. You either got it or you didn't.

The New Yorker once wrote of Frost's public readings: 'This more or less ordinary man, reading to more or less ordinary people, is like no statesman, no celebrity. Robert Frost is quietly overwhelming!' And he was, that never-to-be-forgotten spring morning in Manhattan. From the start he had his audience of champagne guzzlers and Jackie-gapers under his spell. He pretended to no degree of literary artifice or intellectualising. His reading was simple, devoid of any tricks. He came across as a man, not so much reading aloud, but thinking aloud, with a total lack of self-consciousness. And what audience could resist that; for, surely, if a man allows you to catch him thinking aloud, he must be trusted.

He did possess the lovely knack of wandering off, between poems, into little biographical asides. Little details of his family, of his life, that helped round out a picture of the poet standing, in all his ancient, tousle-headed, baggy-suited humility, before his ultra-sophisticated audience. He had been a 'slow starter'. Was nineteen before he had his first poem published. After that, in twenty years he could only manage to have fourteen poems published. All that time he was working at many different things—teaching, editing, and farming. Farming he liked best, but he wanted some affirmation, some recognition as a poet.

So, coming up to his thirty-eight birthday, he told us, he decided to sell his farm and move, with a wife and four young

children, to live in England. Partly because of his poetry and partly because his wife, Eleanor, had a wish to live in a thatched house. It was a good move and he made some great friends among the literary set in England and published his first small book of poems while living there—*A Boy's Will*.

He became friendly with William Butler Yeats, and attended many of the great man's famous Monday night sessions. He would spend hours with Yeats, sitting in his darkly curtained room, talking poetry and politics. When Yeats talked politics Frost was bored. When he talked poetry he was enthralled. He remembered, how Yeats could 'do anything he wanted to with words'. 'The Song of Wandering Aengus' was his favourite of all Yeats's poems.

In England he told us he had become friendly with some of the doomed 'war poets'—like Edward Thomas and Rupert Brooke. Young men who were forced, like flowers in a glasshouse, to bloom, to mature in the crucible of battle.

Frost found Brooke charming, but given to affecting a metaphysical sarcasm, striving to be 'a latter day John Donne'. Brooke had just finished a very serious relationship with a charming young lady known to Frost, who described her as having 'her crowning glory in her red hair, her cleverness in her painting'. Brooke wrote an extraordinarily beautiful sonnet for her, 'He Wonders Whether To Praise Or Blame Her', which Frost, with obvious deep emotion, read for us, his old voice trembling as he intoned the first lines:

> *I have peace to weigh her worth now all is over,*
> *But if to praise or blame her cannot say ...*

But of all the friends he made in England the most dear to him was Edward Thomas. 'The war killed Thomas,' the old poet told us, 'but it also made a man and a real poet of him. The poems Thomas wrote nearer his death are best. You know, the older I get the more I think of Edward Thomas and all those young men who died in their twenties. All that waste of youth and talent.' Frost then went on to read us one of these later poems of Edward Thomas. And his audience was quite stunned by it. Those mostly young New York executives were visibly moved by the lines of the dead young poet, read by this American octogenarian:

> *No one cares less than I*
> *No one knows but God*
> *Whether I am destined to lie*
> *Under a foreign clod,*
> *Were the words I made*
> *To the bugle call in the morning.*

When he finished there was absolute silence; the audience quite obviously transfixed. These young New York executives were made, for however short a time, to think of a life outside their own. And the old poet himself hesitated a little before going on. When he did, it was to tell us how much he had loved the English countryside, and read some more of Edward Thomas and a couple of poems by Thomas Hardy.

After reading the Hardy poems, 'Lizbie Brown' and 'Castle Bottrel', he went on to explain that he had always tried from the very start for a truly natural speech, the language of the common man, he called it. Most of his colloquial rhythms had come to him during the long years of obscurity and neglect; the early years of working at all sorts of odd jobs in New

Hampshire—farming, milling, teaching and rearing his family. But he had never learned, he said, how to mould either vocabulary or metre to his purpose, until he went to stay in England. And another important thing he learned in England was that writing free verse was like playing tennis with the net down. The sentence sense of sound in a poem was everything. The ear did it, all the time. The ear wrote it and the ear was the best listener. The sense of sound said more than any words. There should always be a sense of 'wildness' about a really good poem.

He spent three years in England and published another collection of poems there—*North of Boston*. After that he returned to that country north of Boston, where his roots were and which he loved so very much. For the rest of his life he was to farm and write poetry and travel extensively to give readings. He had, he said, after England found a new confidence, a new certainty, about the function of the poet and the poem.

At this point he invited questions about poetry from his audience. I had thought the response to that invitation would be tardy from such an audience. It was not. It was as if his reading had cast light into dark corners of their psyches, opened some kind of floodgates in them. The questions came quickly. I remember one in particular about how a poem came into being; how did it develop? His answer was a superb description of the genesis and development of a poem. A poem, he explained, was like a piece of ice on a hot stove and must be allowed to ride on its own melting. It could be worked over, once it was in being, but it could never be worried into being. The most precious quality of a poem, he felt certain, was to allow it to 'run itself' and carry the poet along with it.

He was asked another question about how long a good poem might be expected to last. Either a stupid question, or a smart, 'catch' question, I thought at the time. But Frost did not see it like that. A good poem, he felt, would last forever. Though it be read a thousand times, it would forever keep its freshness, as a petal keeps its fragrance. It would never, he said, lose its sense of meaning, 'once enfolded by surprise as it was read'.

Someone then asked him to read arguably his most famous poem—'The Road Not Taken'. He smiled as if he was glad he had been asked, as if that poem meant something very special to him. And in his reading of it, he took all of us there down the tracks of that yellow wood with him:

> *Two roads diverged in a yellow wood,*
> *And sorry I could not travel both …*

By the time he had reached the last lines, '*I took the one less travelled by,/ And that has made all the difference*' the unlikely breakfast-time listeners were completely under Frost's spell. The old poet could lead them anywhere he chose. It was as if he were making the prophecy in that last poem come true. Taking the less-travelled road had indeed 'made all the difference'. We all sensed that here was a man who could will us to follow him anywhere he wanted. The quietly insistent voice; the poems with their eternal note of truth, the soft-sell didacticism, the maple-syrup-coated moral, all conspired to create a special kind of hypnotic effect. He was small, wizened, decrepit; but the difference between him and all of us there had nothing to do with externals, with appearance; the difference was qualitative, not quantitative.

And the old poet had the wonderful gift of knowing exactly when to change course in his reading, when to change the mood. Next he told us of a meeting he'd once had with the Welsh poet, W.H. Davies, at a function they were both attending. Davies went out in the middle of the evening, ostensibly for some fresh air, and seeing a bar across the street, went in for one drink, stayed for several, and then couldn't find his way back. They met just once again, and Davies apologised. Frost read us Davies' most famous poem 'Leisure':

> *What is this life if, full of care,*
> *We have no time to stand and stare ...*
> *A poor life this if, full of care,*
> *We have no time to stand and stare.*

After that second meeting with Frost, Davies went back to England. There was great sadness in the old poet's voice as he told us how his fellow-poet had to sell his poems, printed on penny-ballad sheets, on the streets of London. Eventually the Queen gave Davies a pension to keep him off the streets. Frost said that when he thought of Davies he was reminded of what people felt about 'style being the man'. But he wasn't happy with that aphorism. Style, he felt, was the man skating circles round himself as he moved forward.

At one point, near the end of the reading, after he had read more old Frost favourites such as 'Tree Fallen Across The Road' and 'Fire and Ice', he invited more questions from his audience about poetry. One question was 'What is a really good poem?' To him, Frost said, a really good poem was like a daily walk with a cliff's edge prospect at the end of it. A good poem was the unforced expression of the life he was forced to live. And he said, with great emotion, that he always believed

we would finally be judged by the delicacy of our feeling on where to stop short. Even the beauty of a metaphor, for him, was that it broke down somewhere.

John Berryman once called Frost 'the quirky medium of so many truths,' celebrating the poet's incorrigible caginess, impertinence and mischievousness. Frost always remained basic and elusive. He said himself that he wrote to keep the over-curious out of the secret places of his mind. Yet as I listened to him that morning in Rockefeller Centre, that statement appeared to me half- red-herring, half-contradiction. For, in keeping the over-curious out, he allowed the more sensitive spirits in.

To close, he told us that it was the business of literature to give people something that makes them say, 'Oh, yes! I know what you mean!' It's no good telling them something they didn't know. You must tell them something they did know, but hadn't thought of saying, or couldn't say themselves but would like to. His poems, the old man said, were all set to trip his listeners or his readers headlong into the boundless. In childhood he had left his blocks and toys and playthings lying about where people kept falling headlong over them, forward into the dark. Well, a poem was just like that. A poem should always have a touch of mischievousness about it.

After the reading I gravitated toward the spot where Frost and Jackie Kennedy were chatting to people as they left. I stopped to shake their hands and thank them both for an unforgettable experience. Someone close behind me pressed forward to ask Frost what exactly he had meant, when he stated earlier that writing free verse was like playing tennis with the net down. I was still luckily just within earshot, and heard his

reply. 'Cheating,' he replied, with one of his most mischievous chuckles, 'cheating!'

Leaving the Centre I was suddenly aware of the roar of the morning traffic, and the river of people rushing to work along Fifth Avenue. The bell of St Patrick's Cathedral was ringing out for nine o'clock Mass. I thought of the lives Frost had touched that morning, but could only guess at how lasting the effects of his particular magic would be for each of them. For myself, I am sure the magic will last forever.

The Courage of the Gift

Katherine Anne Porter

It was near midnight when I left my hotel and trudged through the New York snow to the mailbox on the corner. Around me the fronts of the old brownstone houses looked burnished against the blinding whiteness of the new-fallen, crystalline flakes. There were few people on the sidewalks. On the roadway the traffic drifted by quietly, the tyres making a barely audible whisper on the soft, white carpet; the hum of the engines muffled by this first big snowfall of winter, 1962. The cold was numbing.

I had spent the night in my hotel room writing letters to family and friends in Ireland. Even after five months in New York, I still suffered regularly from bouts of intense homesickness; a great, dark cloud that descended inexorably, threatening to crush me. Difficult to dispel, the only antidote was to write home. I had tried a 'night on the town' often enough to know that that didn't work. Writing home did. Long letters that rambled on about how wonderful a place New York was; how much I was enjoying it all. No mention of homesickness. The homesickness was between the lines. When I wrote it that way in the letter, I hoped the folks back home would not notice it. However, by the time I mailed the letters, I was already praying that when they read them they would read between the lines.

At the mailbox on the corner the wind was gusting crazily, as if blowing from all four quarters at once; the snowflakes flying, the snow drifting against the box itself. My fingers were already stiff with cold as I took the letters from under my coat and one by one, began to slip them into the box, making sure they were all properly addressed and stamped. As I had suspected, I had forgotten to stamp the last of the eight.

'Damn', I muttered to myself, 'damn!' The hotel was more than a block away and the stamps were in my room. I turned to go back and bumped straight into someone standing directly behind me. It was an elderly lady, dressed all in black, looking slightly top-heavy in a large, Cossack-type hat that came right down over her face and rested on her nose, like a guardsman outside Buckingham Palace. I apologised—I had not heard her come up behind me—and stood aside to let her have access to the mailbox.

'Forgot to stamp this one,' I said apologetically, holding up the limp white envelope like a flag of truce.

'Irish?' she queried.

'Yes.'

She moved forward to put some letters in the box, saying, 'Wait for me. I've got some stamps.'

'Thank you, but that's alright. I've got some back at the hotel.'

'Which hotel?'

'City Squire.'

'Why, that's two blocks away. And in *this* weather! Come with me, young man. I'm just over there,' and she pointed

across the corner to the lighted, open door of one of the brownstones.

Looking back now over the years I still find it difficult to understand why I went with her. But I did, without demur. It seemed the right—indeed, the only—thing to do. It had something to do with her age and something to do with the tone of voice in which she said 'young man'. I probably would not do it today. Indeed I would probably not be asked today. And it would be most unlikely that I would even go out alone, at midnight, to mail some letters in New York as it is now. As it would be unlikely for an elderly lady to go across the street at night, leaving her hall-door ajar.

But three-and-a-half decades ago New York, for all its dangers, was a different city. So I found myself crossing the corner with this kind old lady in black, leaning into the blizzard and holding her arm, in a token gesture of support, until we reached the little lighted haven of the hallway of her brownstone. There she took her Cossack hat off and as she shook the snowflakes from it, I could see she wore her shining silver hair 'up'.

'In here,' she said, pushing open a door off the hallway and showing me into a wonderfully warm and welcoming room, where a huge fire glowed in a white marble fireplace. She went immediately to a drawer in a writing bureau and produced an envelope with stamps inside it.

'Take what you want. Go mail your letter, and then come back and have a night-cap with me.' Her politely peremptory tone made it half-invitation, half-command.

I took a stamp and thanked her, but she sensed my reticence about accepting her second invitation, and added 'I'm

Katherine Porter. Now hurry, hurry! You don't want to miss the collection. You can tell me your name when you get back.'

As at the postbox I could not refuse her invitation, command or whatever one liked to call it. Her soft Southern drawl, her open, friendly, direct approach brooked no argument. So I went quickly across the windswept street, mailed my letter, and returned.

She was preparing a hot whiskey. 'Sorry, I don't have any Irish. Just a good old rye. Sugar?'

'Please. My name's Bill … Bill Long.'

'And what is Bill Long from Ireland doing in New York on a night like this?'

I was about to answer when she went on . 'Right now, probably the same thing Katherine Porter's doing … feeling a little homesick. Am I right?'

'Yes. Funny thing, homesickness,' I said. 'I thought after boarding school I was finished with homesickness.'

'Never finished with homesickness, young man. Gets worse the older you get and the more you travel.'

'Doesn't seem to bother some people at all,' I said.

'Nothing bothers some people,' she laughed, 'absolutely nothing! They go from cradle to grave without really *feeling* anything.'

As she finished preparing the drinks, I stood in front of the big fireplace and looked round the room. On a table, held between two carved-ivory bookends, were some books—all, I noticed, 'by Katherine Anne Porter'—in different language editions. Lying on the table was a copy of *Ship of Fools*, the novel she had taken twenty years to write. Published earlier

that year, it was one of the undoubted literary 'hits' of 1962, together with Steinbeck's *Travels With Charlie*. Every bookshop window in New York had carried displays of it; a run-away best-seller, it was reputed to have already been sold to one of the big Hollywood studios and a major movie was being talked about.

'Have you read it?' she said, coming toward me with a huge tumbler-full of steaming hot whiskey for me and a large mug of drinking chocolate for herself.

'Yes. I liked it very much,' and then, sensing she was the kind of woman who could literally smell out insincerity or half-truths, I added, 'but the characters! I found so many characters confusing.'

She laughed and said, 'So did I, in the writing. Times I wondered why I put so many people in the story. But that's the way it developed.'

'Frightens the life out of me to even think of taking on something as big as that,' I said.

'Why, are you a writer too?' Her tone was sharp, with a directness that scared me a little. This old lady seemed incapable of being anything *but* direct, and her directness was totally disarming. After ten minutes in her company it was very clear that she didn't tolerate anyone who hedged his bets.

'Well, not exactly.'

'What do you mean? You either *are* or you are *not.*'

'I started life as a journalist, but ...'

'Now ... now you are working in, let me see, let me see! Public relations!'

I could only laugh outright. This old lady was incredibly perceptive. No, not just perceptive. This old lady was clairvoyant. I told her so.

Now it was her turn to laugh.

'No, hardly clairvoyant. Well, not about public relations anyhow. Been around too long not to know the kind of people who go into public relations. The black sheep of well-to-do families. Retired Army and Navy officers. Writers *manqué*. And people like yourself, young man, who have a gift and are afraid to cut loose and follow it through. Courage, Bill Long, that's what it's all about.'

She was right and I knew it, but in the face of such honesty from a total stranger, I was quite speechless. We sat silently for a little while and sipped our drinks and gazed into the logs crackling in the big fireplace. I could sense that she felt she had perhaps gone too far in being so forthright.

But that truly broke down whatever barriers remained between us. We sat in front of the blazing fire and talked. She had talked to me at the mailbox on the corner, she explained, because I looked all 'lost'. The kind of lost look people get when they are homesick. And she added, she knew all about being homesick. She was seventy years old now, had been on the move most of her life, but had always been, and would always be, homesick herself. Having heard my first words of reply to her, there in the snow, she knew I was Irish, and that was enough for her. She liked the Irish. At intervals she went to the kitchen to prepare another hot whiskey for me and a chocolate for herself, and I stoked the fire. I know that she sensed I was at some kind of crossroads, and she also believed, as I did, that nothing really happens quite by chance. There is a

'plan' for everything. Some kind Fate had pre-ordained that I should walk with my bundle of homesick letters to that postbox on the snow-drifted corner, and that she should be there too. And for a reason.

I have talked to many people, in interviews and in private conversation, about their art and what it meant to them, but never to anyone to whom that art was a religion, the way it was to her. When Katherine Porter talked writing—her art, she called it—nothing, but nothing, stopped the flow. She had long ago, she said, as a young girl in India Creek, Texas, written a letter to her sister saying she 'wanted glory'. Even then she knew that by that she didn't mean just fame or success or money. She meant, all those years ago, that she wanted to be a good writer, a good artist. She knew, very early on in her life, that she had 'some kind of gift'. But she also knew that one of the marks of the gift is to have the courage of it.

'Without the courage,' she admonished me across the blazing fire, 'without the courage, the gift is useless! Courage is the first requisite. *You* must be true to *you*. Look at the thumb-print! Yours is not like any other, and that thumb-print is what you must go by ... always!'

'I agree,' I said, 'about having the courage. I quite agree. But it's not easy, is it? I mean, can you know how big your gift is? How can you know if it's going to be worth it?'

'You can't,' she said, a hard edge of impatience in her tone, 'you can't, while you're still unproven. It's an act of faith. A great leap in the dark. And very often you have to give up a lot to do it. You see, writing is a vocation. You have to live a monastic life almost to do it well.'

'Don't know if I'm quite ready for that kind of single-minded commitment.'

'You'd better be if you ever want to know how good you are. You can't play footsie with it. Writing is an art, and I honestly believe, if you treat it in a take-it-or-leave-it fashion, it will *leave* you. A talent, a gift, is not a thing you can nail down and use as you want. You must be willing to let *it* use you, too.'

I knew deep down that this old Southern belle was right in everything she said. But I was still afraid, and in an effort to evade answering her unasked question of when I intended to leave everything and write, I changed the subject. I told her about my meeting with John Steinbeck a few months back, at Sag Harbour. She liked Steinbeck. More than just liked him. She had a great respect for him.

'*Travels With Charlie* is a great book,' she said. 'One of the few books that outsold *Ship of Fools* this year. He's really got the measure of America, you know. Like none of his contemporaries. And besides, I like the kind of people he writes about. Even in his fiction. They're real people.'

'Yes, they certainly are,' I had to agree, loving Steinbeck myself.

'Not like Scott Fitzgerald,' she went on. 'Didn't like the way he wrote, or the people he wrote about. How did we ever canonise Fitzgerald the way we did?'

When I asked her what exactly she meant by 'real' people, she laughed and said, 'Oh, the kind of people one meets. Or can meet. Like homesick Irishmen on snowy New York street corners at midnight!'

After that I finished my night-cap and left. She made me promise to ring her in a day or two. There were some books I should read. She would make me a list.

Before I left she remembered something about public relations that she just had to tell me. Had I ever seen a film with Jack Lemmon, called *Days of Wine and Roses?* I had, as it happened, and I had liked it very much.

'Well, that said it all about public relations in one little scene,' she laughed, and as she began to recount it, I remembered it myself. The scene where Jack Lemmon, playing the alcoholic PR man, is asked by the craggy old Charles Bickford, playing the father of the girl Lemmon is in love with, what he does for a living? When Lemmon tells him he is in public relations, the old man is totally unaware of what that means. Lemmon tries to explain and ends by saying that when one of his clients does something good he's gotta get out there and tell the world about it. The old man reflects for a moment and then asks what he does when one of his clients does something bad?

'Don't go to the movies much,' Katherine said, 'but I saw that film twice. Charlie Bickford and I are old pals. We go back to the old Pasadena Playhouse days.'

Two days later, before I got round to ringing her, she rang me at my hotel. She said something had come up that she felt I might benefit from. The following evening a friend of hers, the writer Paul Gallico, was giving a lecture at Columbia University. She thought, in the light of our conversation a few nights back, that the lecture might be of interest to me. Mr Gallico was addressing the question of 'Having the courage of the gift ... or not; as it applied to beginner writers.' If I was

free, she would love me to accompany her. I accepted with alacrity and warm thanks. One of the things I had learned early in life was how to recognise what I thought of as 'gifts of fate' when they were offered. And this was certainly such a gift. Paul Gallico was a writer I had loved ever since reading *The Snow Goose*, in 1941, the year it was first published, when I was nine years old.

The lecture hall was crowded next evening. There was always a veritable army of would-be writers stalking the metropolitan jungle of New York. And many of that army had come to hear some words of wisdom from the kindly Paul Gallico. Derelicts and near-derelicts; a small coterie of those half-way to becoming writers, already working on newspapers and magazines; some, like myself, round pegs in square holes—public relations executives, bank clerks, shop assistants, accountants, engineers, real estate operators, a couple of priests, a rabbi— and a group of full-time students from the Columbia Arts Faculty. All of us, to a greater or lesser degree, unsure of our talent and scared of commitment, yet inexorably drawn to this business, this trade, art or craft—this madness of writing. In that crowded place, waiting for the lecture to commence, the mood of excitement and contradictory reticence was palpable. The chattering groupies; the silent loners; the ones, like myself, brought along as guests—all reminded me of something I had once heard my grandfather say in the long-ago land of my youth. He had referred to an elderly local farmer, who was displaying great tardiness in asking his 'girlfriend' of thirty-years to marry him, as being 'shy, but willing, like an ass at a thistle'. Looking round at the motley assembly, I smiled to think of how apposite the old man's metaphor was.

Sitting beside me, Katherine Porter saw my smile. 'Share it,' she said, with that directness, that half-invitation/half-command I had noticed at our first meeting. So sitting there waiting for Paul Gallico to appear, I told her about my grandfather, his great sense of the ridiculous, and his wonderful penchant for conjuring up at will the perfect metaphor.

'Was he a writer?' she asked.

'No. A peasant farmer. A *seanachi.*'

'A what?'

'*Seanachi.* It's the Irish for 'storyteller' in the oral tradition.'

'From the metaphor you've just given me, looks like he had a talent for choosing *le mot juste.*'

'Yes. I suppose so. He did take the trouble to get the right word.'

'Not only the *right* word,' she said, 'the *absolutely right* word. And that's important. *All* important. You see there's a word that is *just* right for what you want to say. Search till you find it. Don't settle for anything less. You see ...' Katherine continued, only to be interrupted by the announcement that Paul Gallico would now commence his lecture. However I made a mental note to ask her to continue when the lecture was over.

The lecture that followed was the most important I have ever heard. Gallico was an amiable, ambling giant of a man, even bigger than I had imagined from his photographs. With a minimum of preamble, he told us he had been born in New York in 1897, of Italian-Spanish extraction, and had graduated from Columbia in 1921 with a Bachelor of Science degree. His

original intention had been to study medicine, but very early in life he had decided he wanted to be a writer. So against the advice and wishes of his family he had opted out of medicine and become a sports journalist. From that he had progressed to writing short stories and feature pieces for the glossies; making his big breakthrough in 1941 with *The Snow Goose,* a classic story of Dunkirk, which became an international best-seller.

After this very brief introduction he invited questions from the floor on any aspect of getting started as a writer. All kinds of questions, zany and sensible, were flung at him. He responded courteously and in detail. Two of the questions, or rather his answers to the questions, had a big impact on me that evening, and the import of what he said has remained with me ever since. Indeed, his answers to these two questions have remained typed out and pinned above the desk in my workroom for the past thirty-six years. They have been beacons that kept me on course in many a stormy sea of indecision and self-doubt.

The first question was: 'Mr Gallico, how would you define real communication?' And his answer: 'Real communication is summed up in two words— 'touching' and 'moving' your reader. As many people confuse movement with action, so do too many writers confuse the dissemination of information with real communication. There is no connection. Absolutely none.'

The second question came from a young man who was worried about not being able to get started on a short story he wanted to write. His problem: he couldn't find a theme big enough to be worth writing about. Paul Gallico's answer was inspired, and came round at the end to what real

communication was all about. 'You shouldn't worry about how "big" your theme is. You see, the world was never changed by young men, or women, who flew to the moon, or risked their necks to write a piece about their sensations. But sometimes, if they could have a simple idea, harness it, think about it, write it out in simple, clear fashion; then publish it where people might read it, they might just succeed in moving this tortured old planet an infinitesimal fraction in the right direction.'

Ever since, it has always seemed to me that that should be the prime aim of every real writer; his or her real, and only, motivation. Not money, not success. For the real writer, if that ineluctable maxim is honoured, then there will always be a sufficiency of money. Success is something else.

After the lecture Katherine Porter and I took coffee with some of the alumni who had helped organise the evening. I was introduced to Paul Gallico. We talked for ten or fifteen minutes about the Irish writer he liked most—Yeats. I mentioned Joyce, but he didn't like Joyce and our conversation drifted to other things and he told me of the idyllic interlude when he owned a house 'on a hill-top at Salcombe in South Devon'. He lived there for over a year, and much of the atmosphere of that wonderful place went into the writing of *The Snow Goose* a few years later.

Coincidentally, over thirty years later, back in Dublin, I worked for several months on a radio programme with Bob Gallico, Paul's son. A long-time resident in Ireland, Bob is in so many ways his father's double; the same Latin features, the same deep voice, the same fine, old-world courteousness. Though not a writer, Bob shares his father's single-mindedness for a speciality—classical music.

On the way back to her brownstone in the taxi, I reminded Katherine Porter that she had not finished what she was saying about *le mot juste,* when the lecture had commenced.

'I remember,' she said, 'something very important. A pupil of mine in a writing course once asked me whether he should use 'big' words or 'small' words. What a question! I gave him the only possible answer. Whether the word had one syllable or ten didn't really matter. That's not how you decide which word to use. You must use the right word to describe what you want to describe—*le mot juste*! Then I told him it was all relative anyway. Reminded him that when William Faulkner was asked a similar question he said that he hoped every page he wrote would send his readers rushing to the dictionary! And Hemingway, when asked, said he hoped no word he ever wrote would send his readers to the dictionary! And they were both eminently successful communicators. Both won the Nobel. So, in the end it's down to the individual writer. It's that thumb-print I talked about the other night.'

Two weeks after the Columbia evening I was given an assignment in Mexico City. I rang Katherine Porter to tell her I would be leaving within two days, and invited her to lunch. We ate at a little Creole place in The Village. She asked me if I had decided what to do about my future, and was delighted when I told her I had already decided to tender my resignation and would be going back to Ireland as soon possible. But it might take some time to make this arrangement.

'You are going to write?'

'Yes, for better or for worse.'

'Good. You will never regret it. You have already made your Act of Faith. What are you worried about?'

'Style,' I said, 'I know how important style is for a writer. How do I go about cultivating ...'

'You don't,' she said emphatically. '*You* are *your* style. Aristotle said "Style is the man". You write and write. You develop yourself and out of that comes what they call style. But you must lose all consciousness of it. Oh, you could cultivate a style, but it would be like any cultivated thing—artificial.'

'But I read somewhere, just the other day, that we live in a time when a really successful writer should cultivate a sophisticated style ...'

'Stop!' she interrupted me, 'Stop right now! We have two things here. "Sophisticated". I wonder, do most of the people who use that word as if it were some kind of talisman, really know what it means! Looked in my dictionary the other day. It's described, among other things, as "a veneer, an imitation of the real thing". So much for sophistication. And "success" is a word that has no place in the vocabulary of any true artist. There is no success, no failure for the artist. Just writing the best you can.'

At the end of lunch she told me she was going South herself the following week, to spend some time with what remained of her family at Indian Creek, Texas. 'You see,' she said with a sad, enigmatic smile, 'after all these years I am still homesick.'

Late that night, alone in my hotel room, I began to read a book of her short stories, which I had picked up in The Village the day after first meeting her. It was *Flowering Judas*, her first published work, going back to 1931, the year before I was born. I found a passage in the title story which mirrored the kind of life the young Katherine had experienced, eking out a

living doing different jobs—teacher, dancer, actress. A time she described as preparing to be the artist she eventually became:

> *Precisely what is the nature of this devotion, its true motives, and what are its obligations? Laura cannot say. She spends part of her days in Xochimilco, nearby, teaching Indian children to say in English, "The cat is on the mat".*

I never again saw nor heard from Katherine Porter, who died in 1980, aged ninety. Yet in all the years since we met I have never regretted making that decision to leave New York and return home to Ireland to write. I can honestly say that I have never thought of my work in terms of success or failure, only in terms of reaching people, touching people. And also ever conscious of Katherine Porter's admonition to have 'the courage of the gift'.

The most rewarding thing for me is to occasionally have some affirmation of what I am trying to do. And that does happen, more often than one would think. The letter from a man who, early one morning while driving to a remote midland lake, determined to drown himself, heard a short talk of mine on radio and changed his mind. Literally dozens of letters from people who read my account of my own heart transplant, *A Change of Heart*: people whose lives had been touched directly or indirectly by heart disease, and who were helped to cope by what they read. Or countless letters and phone calls from listeners to my radio programmes. And they are just some of the ones who are kind enough to contact me. Hopefully what I write bears fruit in the hearts and minds of many others; men and women I shall never know—or know.

Every day I sit down to write remembering Katherine Porter's advice … 'Always know where you're going, know what your goal is. After that how you get there is God's grace.' And so far, God's grace has worked for me.

Travelling First-Class

David Niven

In the days before Idlewild Airport was renamed Kennedy, and when the First-Class 'decks' were still relatively underpopulated because of the relatively exorbitant fares, I flew regularly from Idlewild to London's Heathrow. And I always flew First-Class; not because I was well-off or prodigal or ostentatious, but because I worked in the public relations department of an international corporation. That corporation in its wisdom insisted that its executives should always travel First-Class; it was a matter of projecting the correct corporate image; company prestige was at stake.

But there was, I am sure, a more subtle reason for this insistence on travelling First-Class; there was, I felt, an insidious hidden agenda at work. You were encouraged to develop, at the company's expense, certain 'tastes', for food, drink, accommodation; 'tastes' you could never hope to afford to gratify out of your personal earnings. Slowly, subtly you were introduced to a sophisticated life-style—the 'expense account' life-style—that became important to you. It became a kind of umbilical cord of dependence linking you to the company. You thought twice before changing your job, never sure that you would continue to enjoy the same standards with another company. If you ever doubted the validity of the work you were doing and thought of changing to something that

gave you greater job-satisfaction, greater personal fulfilment, you needed that much more strength of will, that much more integrity to make the change.

At executive level, with most international corporations you were a mere chattel; highly-paid, well looked after in every possible way, but nevertheless, a chattel. I remember, years after I had joined the company, coming across quite by chance a letter in my personal file, written by the personnel man who had head-hunted me. It described the several meetings between us when I was holding-out for more salary, and culminated with the chilling statement: 'I think the salary negotiations are over now and Bill Long, with some few extra perks thrown in, can be bought for X dollars per annum.' I had never thought of myself as being a commodity that could be bought. Obviously others did. Within six months of reading that letter I had tendered my resignation, and become a freelance writer. I have never worked for a salary since, never been bought or owned by a company.

Notwithstanding the hidden agenda, I enjoyed this aspect of my time in public relations. I travelled a lot, enjoyed hotels and restaurants that otherwise I could never have afforded. My palate became 'educated' in a way I would never have imagined. And I met people, through travelling First-Class, who would otherwise, have moved far outside my orbit. And ultimately, when the time came for me to move on, I found the moral courage to cut the umbilical cord, ironically with the help of some of the people I would never have met if I had not been travelling First-Class.

I remember one humid July afternoon boarding a Heathrow-bound plane at Idlewild, and finding I was the only

passenger on the First-Class deck. In those days when the New York-London trip took several hours more than it does now, the prospect of sitting all alone did not appeal to me. However, just as we began to taxi out to our runway, the plane came to a standstill and the Captain, apologising for the delay, announced that we had a last-minute request to take a late-arrival on board.

From my window I could see a white car, with VIP in large red lettering on its side, speeding along the apron at the periphery of the runway. Soon I heard the trundle of the mobile stairway and the doors opening, and a passenger came aboard and was shown to the First-Class deck. The stewardess steered him to a seat at the far side, far away from me as it was possible to put him. After a minimal delay we were rolling again and soon airborne. Only then did I look across to see my fellow-traveller. It was, unmistakably, David Niven.

After take-off I busied myself with some paper-work which I needed for a meeting in London next morning. Nearly an hour later, a stewardess came with a breakfast tray. I instantly put aside my work, for one of the best things about long-distance flights in the Sixties was the incredibly high quality of the food on the First-Class deck. The plastic airline food of today hadn't yet been invented. Just as I was settling in to eat breakfast, I was conscious of someone standing over me. Looking up I was surprised to see David Niven standing there, smiling that same charming smile I had seen him smile in a dozen good, bad and indifferent movies.

'I say,' he said, half-apologetically, 'My name's David Niven. Would you mind awfully if I joined you for breakfast? Hate eating alone, old chap. And these long flights can be frightfully boring with no one to talk to.'

Before I could answer, the stewardess had arrived with his breakfast tray, assuming, correctly in my case, that nobody would object to breakfasting with David Niven. As he settled himself beside me, I introduced myself. He shook my hand warmly, seeming especially delighted that I was Irish. I made a little joke about his feeling he had to introduce himself, when he was so obviously David Niven, and so instantly recognisable.

'Well, without being big-headed, dear boy,' he said, 'I used to think that myself for many years. Indeed it seemed rather big-headed to go around introducing oneself as David Niven. Then, on a flight from Paris to Athens, some years ago, I struck up a conversation with a fellow-passenger, a French-Canadian without saying who I was. We shared a meal, several drinks, and swapped some great stories and as we prepared to leave the plane in Athens, this chappie said to me, quite seriously, "Been great talking to you. And look, I'm really glad you didn't try to pass yourself off as that film actor, David Niven. You do look very like him, you know. But I would have seen through it after just a little while with you. Your mannerisms are all different. And I've seen the guy in enough films to know! You'd never have fooled me."'

This story, told over breakfast, set the tone for the rest of the trip. We talked incessantly, we laughed, we ate two other meals together, and consumed almost two bottles of whiskey. Without any doubt, David Niven was the best raconteur I've ever met. In him the twin talents of story-teller and consummate actor were perfectly wedded. He never tired, all through that long flight, of telling story after story, very often against himself, laughing so heartily at his own jokes that I laughed also, sometimes to the point of tears. He had this

incredibly infectious sense of the ridiculous, though on several occasions he lapsed, momentarily, into a serious mood, which gave me the impression that very like the character in the old music-hall ditty, he was a man 'laughing on the outside … crying on the inside'.

He apologised for holding up our take-off, but explained that it was important he caught this flight. An ancient aunt had died suddenly in Scotland and he was dashing there for her funeral. After that he would go straight 'home' to Switzerland for a few days, before rushing back to America on some film business.

'You see, old chap,' he said, as we started into our second bottle of whiskey, letting his jester's mask slip for an instant, 'I feel like some sort of bloody nomad. Got two lovely homes in Europe, another in California, and I spend so much time dashing round working to make enough money to keep them, that I hardly ever get to live in them.'

He talked very little of his film career, but did talk of how much he would love to have the time to write more. Twelve years before he had written his first book, a novel called *Round The Ragged Rocks*, a passably entertaining comic novel.

'Reviewers hardly noticed the thing, old boy, and it made me damn all money. Still, I did enjoy writing it.'

I asked him if he had plans to write any more books. He said he had; would love, he said, with a mischievous smile, to write his memoirs! And he did, in two wonderful volumes, *The Moon's a Balloon* and *Bring On the Empty Horses*. But the first of these did not appear for another ten years. A second novel, *Go Slowly, Come Back Quickly* appeared in the early

Eighties, but it is generally agreed that the memoirs contained the best of his writing.

During that flight, I also discovered that unlike many good talkers, David Niven was also, surprisingly, a good listener. He asked me many questions about Ireland and Irish writers and listened with great interest to my answers. In the course of one response, I mentioned that I had, as a boy of twelve or so, seen T.H. White in a Dublin pub.

'The *Once and Future King* man?' Niven queried.

'Yes.'

'Why, he was a teacher at my old school, Stowe! But we just missed each other there, old boy. I left Stowe, as a pupil, two years before he came there as a master. Had a jolly good Headmaster at Stowe, J.F. Roxburgh! Same chap who hired White. Eccentric sort of fellow, old J.F., but a jolly good friend to me. Kept in touch with him long after I'd left. I gathered White was a kindred spirit. Bit eccentric, just like himself! J.F. often mentioned White when we met. I always remember what J.F. used to say about Stowe: "Stowe is no ordinary public school. If we do not fail wholly in our purpose, every boy who goes out from Stowe will know beauty when he sees it all the rest of his life."'

'And was that true?' I asked.

'Yes. Yes, I think it was, old chap. For me anyway. His influence on me was tremendous. And you know, looking back on it, I was a nasty little blighter in those days. But old J.F. knocked me into some sort of shape. Taught me some things I've never forgotten … about grace and elegance and decent behaviour. Wonder if he had the same effect on White?'

I did not presume to answer that question, though I felt, from my one brief encounter with White, and my reading of everything he'd written, that he indeed had that innate ability to perceive and appreciate beauty, in its many manifestations, throughout his life.

Three meals, several bottles of wine, and all those whiskeys later, we approached London Heathrow in a decidedly mellow mood. The sight of the city lights in the distance, made Niven lapse into silence for the first time since leaving New York.

'Good old London!' he said, with a sad smile. 'I do love it. Must tell you one last story, old chap. Absolutely true. Just last month almost got a great film part, but the bloody producers thought at over fifty I was too old! Old friend of mine, Ian Fleming, used to work on the Foreign Desk at the *Sunday Times,* but left to start writing thrillers. Suggested me as his first-choice for the leading role in the film of the first of his James Bond books. Marvellous part and looks like it's going to be a long series. But too old, old chap! Part went to Sean Connery. Hard luck, what!'

Before we parted at Heathrow he gave me his card, with an address in California, and I gave him mine with the address of the Fifth Avenue office where I was based. He said that when he returned to New York, in two or three weeks time, he was throwing a party at the Waldorf for all his East Coast friends. He would love me to come, and bring a friend if I wished. He would contact me with the details when he returned to New York. If that actually happens, I thought to myself, it will be great. But I put it away in a corner of mind, as promises to keep in touch very rarely materialise. However, returning to New York three weeks later, I was due a very pleasant surprise.

On arrival at the office, one of the two Puerto Rican girls at reception went through the messages that had piled up for me in my absence. At that particular time in New York, almost every large corporation had its quota of young Puerto Rican women. It was as if somewhere down in Puerto Rico some agency had decided to clone these beautiful, elegant creatures, train them to be hyper-efficient secretaries and receptionists, and then flooded the New York market-place with them. Ever-smiling, they always looked immaculately groomed, and spoke perfect English with a very neutral accent.

'And Mr Long,' the receptionist said, 'just one last message here. Two days ago somebody rang for you, and said his name was David Niven ...'

Her voice trailed off into silence, and awaiting my reaction, she smiled at her companion on the desk. A knowing smile, as if the real David Niven couldn't possibly be ringing an Irish 'paddy'.

'Yes?' I queried, amused but not showing it. 'Did he leave a message?'

'Yes,' she said, a little nonplussed. "He said the party was on this coming Friday night ...?"

'At the Waldorf?' I interrupted.

'Yes,' she answered, distinctly perturbed now. 'He would like you to ring him. He left a number. But perhaps it was just a practical joke. No?'

'No,' I said politely, adding firmly, 'Please get Mr Niven for me, soon as you can. I'll be in my office.' And so I walked away, trying to suppress a smile.

Five minutes later my phone rang. It was the Puerto Rican receptionist. She was totally abashed.

'Mr Long. I have Mr David Niven on the line for you.'

'Thank you, Helena,' I said, and from my amused tone of my voice, she knew that I had both enjoyed the 'joke' and forgiven her scepticism.

I agonised for days about who to take with me to the party. Eventually I decided to ask my Senior Vice-President, who had treated me exceptionally well since joining the Company. I thought it would be a good opportunity to say 'thank you' and, in my naivety, also impress him with the kind of friends I had managed to make while travelling First-Class. Further, he was a middle-aged, eligible bachelor, well-known for his collection of chic girlfriends. When I asked him if he would like to be my guest at a forthcoming party, he was interested.

'Sure. When?'

'Friday next.'

'Gee! What a pity. I've already been asked to a party on Friday. Where's yours?'

'Waldorf.'

'What a coincidence. So's mine! Whose party?'

'David Niven.'

'You gotta be jokin' kid! That's mine too. My girlfriend's a friend of his.' As it happened, his current girlfriend was the actress Shelly Winters, and the three of us went together.

The Niven party at the Waldorf was a night to remember forever. Indeed it was two nights to remember forever. It started on Friday night with a very lavish dinner for more than one hundred guests, went on right through the night and

continued with breakfast on Saturday. After breakfast, what David referred to as 'the sprinters' went home, and the 'stayers' remained. Rooms were laid-on for those remaining, and after a sleep and a bath, the 'stayers' continued to party through Saturday night and into late breakfast on Sunday morning. After breakfast we departed, drifting out of the hotel in little groups of three and four, eyes smarting in the bright New York sunlight.

On my way out I met another party-goer, a distraught lady in search of her husband who'd been missing since Saturday night. I helped organise a full-scale search and the errant husband was eventually found, fast asleep among the flowers, in one of the enormous window boxes adorning the front of the hotel. He was quite oblivious to everything, even the location of his bed of flowers hundreds of feet above the New York street. He had crawled out there in his cups the previous night to get some fresh air. Waking him was a very delicate operation. We had to ensure that he didn't attempt, with the shock of being wakened, to get out on the wrong side of the bed. If he had, the consequences would have been fatal!

I never saw David Niven again after that party, and I was living back in Ireland when I heard news of his death in the summer of 1983. He died in his favourite place, his Chateau d'Oex in Switzerland of amyotrophic lateral sclerosis—motor neurone disease—after a long, brave fight. At his funeral there, the Lutheran minister read some very apposite lines from an Hilaire Belloc poem:

> *From quiet homes and first beginning*
> *Out to the undiscovered end,*
> *There's nothing worth the wear of winning*
> *But laughter and the love of friends.*

A Touch of Divinity

Aeron Thomas

I first met Aeron Thomas, Dylan's only daughter, when I made a radio documentary, *Singing Ark, Flowering Flood,* about her father in 1988. Then aged forty-six, Aeron had already established her own reputation as a published poet, lecturer, and reader of her father's work. It was absolutely essential to the success of the documentary that she should be a contributor. But from all I had heard, she was a very private person, did not encourage interviews, and might be difficult to enlist for the programme.

I had been told by a close friend of hers that she deliberately eschewed anything that even hinted of the 'bohemian', as she felt that life-style had contributed to her father's early death, and she was determined to protect her children, Huw Dylan and Hannah, from such dangers. She lived with her husband, the Welsh tenor Trefor Ellis, and the two children in a quiet suburban estate at New Malden in Surrey. I contacted her there, initially by phone, and then by letter, introducing myself and outlining my plan for the documentary. Fortuitously, she liked the idea from the start, and it was obvious from the moment we met that we had the common ground of a great love of her father's work. Very soon it was agreed that I should stop over in London while en route to Wales, and come down to interview her in New Malden.

On arrival I had tea and we talked for a while about Dylan. Then it was straight down to recording the interview, which would in due course contribute to the documentary. The interview went well and afterwards she suggested we should go for short walk and get some fresh air. She led the way to a sports ground near her house, where a local cricket match was in progress, and we walked round and round the periphery of the field. It was an end-of-summer evening, and as we walked and talked, we became oblivious of our surroundings, only vaguely aware of the clicking of ball on bat, the sound of voices raised in friendly argument, and the occasional encouraging handclap.

The summer twilight was surreptitiously invading the field, and towards its centre, the once-clear figures in their 'whites' were indistinct grey blurs. Eventually these forms were swallowed up in the enveloping gloom, but the players, anxious to finish the innings, played on. Yet the only indication we had of the game still in progress was the muffled calling of the players to each other and the clear, sharp click of unseen ball on unseen bat. But after the sound of ball on bat there was silence, for the greensward was too thick and soft and the ball made no sound as it landed. I was, as I so often am, reminded of a line or two of poetry, and on this occasion they were lines from one of Dylan's own poems, which I spoke aloud as we walked: *'The ball I threw while playing in the park/Has not yet reached the ground.'*

'Oh, yes,' Aeron said. 'That's one of my favourites.'

'"Should Lanterns Shine",' I said, naming the poem, and as we turned and left the field to walk back to the house, we both quite spontaneously started to recite from it:

Should lanterns shine, the holy face
Caught in an octagon of unaccustomed light,
Would wither up, and any boy of love
Look twice before he fell from grace.

Half-way to the house we finished the poem and so walked on in silence. After the magic of Dylan's words anything we might say would sound very ordinary, and we both sensed that. Yet I thought then, and still do, that it was wonderful how two people who had only just met for the first time, should be so on the same wavelength. And when I left New Malden later that evening I felt that, even if I never saw this woman again, she would always remain very special to me.

When broadcast, the documentary was a signal success, winning a Jacobs Award for the Best Radio Documentary that year. Aeron rang to tell me how much she had enjoyed the tape I'd sent her. She also said she would be sending an invitation to a reading, by the Dylan Thomas Society, of her father's 'Return Journey' in Swansea later that summer.

The reading, given in Oakleigh House School near Cwmdonkin Park, was wondrous; the mellifluous Welsh voices getting every nuance of the script just right; wringing every last ounce of humour and pathos from it. Afterwards, in the gathering summer dusk, Gilbert Bennett, Chairman and founding member of the Dylan Thomas Society, took me across Cwmdonkin Park to show me Dylan's old home at 5, Cwmdonkin Drive. A year or two younger than Dylan, Gilbert had been taught by Dylan's father, and more than anyone I know, has fostered and promoted Dylan all his life. As we crossed the near-deserted park, The Narrator's words from the

reading we had just heard were still fresh in our minds: *'Dusk was folding the Park around, like another darker snow ...'*

As we went out of the Park and walked slowly past the house where Dylan had played as a boy, the lights of the middle-class suburb of Uplands were coming on all round us. Yet the house, long-since passed out of the family, was dark and unoccupied. Across the Park, through the trellis of trees, we could see the brightly lit school, and the last of the evening's guests as they lingered over the last of the strawberries and cream, and drank the last of the summer champagne.

After that summer visit to Swansea there was a long silence until sometime in the winter of 1990 when Aeron sent me a copy of her own book, *Poems and Memories.* The verse consists of nature poems, poems of her childhood and some 'Zen' poems, written after she had become interested in Zen Buddhism, while the memories of the title consist of prose pieces about Laugharne and life at 'The Boathouse', where the family lived before her father died. I fell totally under the spell of the book, particularly the poems and prose pieces about Laugharne. Having been there just once to record the documentary, I had fallen in love with the little town, and had promised myself I would go back sometime. Reading Aeron's poem, 'Later Than Laugharne', I was convinced I must go back sooner rather than later. What's more, certain lines from it kept telling me there was another radio feature waiting to be made.

> *... And the thrill of peeping through*
> *the keyhole (I was always the most naughty)*
> *to see my father writing his poems about*

gulls, hills and cormorants on estuaries
which he saw through his wide-vista window,
as he sat, bent, writing in crabbed letters,
pressing against the hard surface of the
kitchen table that was his desk.

We were poor those days
though I can't remember being poor
in Laugharne, in those balmy,
never-to-be-forgotten days,
green and golden …

Reading those lines, I was back in spirit in Laugharne, walking along the cliff-walk to 'The Boathouse'; down through the tunnel of the overhanging, immemorial, trees, so beautifully evoked by Dylan in his own poetry. And so the combination of those two images—the ten-year-old girl, mischievously peeping through the keyhole of her father's workroom, and the sunlight filtering through the ancient trees—gave me the idea for a new radio documentary. Entitled *Parables of Sunlight*, it would be a 'return journey' for both Aeron and myself. We would start at 'The Boathouse' and then visit each of the several residences in the town where the Thomas family had lived. At each location Aeron would talk to me about her childhood memories of the particular place and read some excerpts from her own poems and prose. I would read from her father's work; poems and prose written in each particular location. We would end at Dylan's grave in the hillside cemetery, with its simple white, wooden cross.

I rang Aeron and outlined the idea to her. She happily agreed to do it, and so, in the late summer of 1993 I went back to Laugharne to meet her and make the necessary recordings. The weather was magnificent; cloudless skies, pleasantly

warm, the last of the summer tourists making their 'Dylan Pilgrimage'—the round of places associated with the poet. The inevitable tour coaches were parked under the Castle wall near the sea, as near as you could park to Dylan's Walk, the winding cliff-path leading along the estuary edge to the Dylan Thomas Museum at 'The Boathouse'.

We stayed in Castle House, the refurbished country house, now a guest-house, from whose gardens a wicket gate leads into the grounds of the old castle. In the 1930s and 40s Castle House was the home of the writer Richard Hughes, who wrote *A High Wind In Jamaica*. While Hughes was away at the war, the penniless Thomases, Dylan and Caitlin, lived there as 'non-paying guests' in 1941, two years before Aeron was born.

We were 'paying-guests', yet Aeron was greatly moved to be given the room on the second floor, which had been her father and mother's bedroom over forty years before. From it she could see, over the ramshackle, dilapidated roofscape of the little town, the gaunt bulk of 'Sea View', where her parents had lived before the war in, for them, the inevitable rented rooms. Rooms which in 1938, Aeron explained had no electricity. Rooms in which guests, among them the painter Augustus John, the poet Vernon Watkins, and the composer Dan Jones, all friends of Dylan's, had gone to bed with the aid of candles stuck deep in the necks of empty beer bottles. And below her window Aeron could see in the Castle grounds, The Gazebo, in which her father had written many of his prose pieces, including *Adventures In The Skin Trade*.

I told Aeron I had a wonderful view from my room on the first floor, which overlooked the estuary—Dylan's *'Heron-priested shore'*. I was sure many of the places I could see must

be associated with her father, and so before dinner she kindly came and pointed out to me across the estuary, the hills and fields around Llanstephan, the area of 'Fern Hill', where her grandmother's family, the Williams, had farmed for centuries. And the tiny church on the hill at Llanybri, described by Dylan as *'The sea wet church the size of a snail, with its horns through mist'*.

At breakfast next morning, Aeron was overjoyed when the owner came and sat with us and told her, 'The people of Laugharne have a lot to thank your father for.' Afterwards she explained to me that in forty years of visiting Laugharne, it was the first time she had heard a complimentary remark about Dylan. It had always been complaints of how he had ridiculed the town and its inhabitants in *Under Milk Wood*.

'Of course,' Aeron admitted, 'as any good writer would, he had used the town as a model for Milk Wood. He was an inveterate eavesdropper, as most writers are. He would go to 'The Browns'—Brown's Hotel—every morning, to sit in the kitchen and sip beer, listening to the town gossip relayed by the kitchen staff.'

But the characters in the famous 'play for voices' were, like most finely drawn characters, composites of many people. Though there was, Aeron said, a butcher's family in St Clear's, just a few miles down the road, which swore that their father, Eynon Butcher, had been, in every detail, 'Mr Beynon Butcher' in *Under Milk Wood*. And one of Laugharne's ladies had once told Aeron that, fifty years before, she had given the names 'Rosie Probert' and 'Duck Lane' to Dylan. These afterwards made famous as the name of the town prostitute, and where she lived, in the play.

After breakfast we went the long way round to 'The Boathouse', going down the hill into the lower part of the town and along the edge of the Square under the wall of the castle. Aeron, looking across the Square to where the neon-signed 'Dylan's Diner' looked particularly garish in the morning sunlight, was reminded of having seen, on her various visits, how the entrepreneurial types had set up here in an effort to cash in on the Dylan 'industry': Dylan's Bar, Dylan's Diner, the Under Milk Wood Café, Rosie's Place.

She thought it so very odd that, in the light of all this spurious development, the Town Council had resisted giving Dylan's name officially to the old Cliff Walk that led from the Square along the foreshore to 'The Boathouse'. But eventually, she said, good sense, with a nudge from pragmatism and expediency, prevailed, and the path was newly signposted 'Dylan's Walk'.

When we arrived at 'The Boathouse' the first visitors of the day were already wandering about the rooms; looking at the memorabilia, listening to the tapes of Dylan's sonorous voice booming out of the skeletal wooden cabinet of an ancient 1930s wireless, and watching videos of the poet's life in the upstairs rooms. Out on the patio, formerly the garden in which she had played as a child, Aeron was approached by three American ladies who had just bought one of her father's books in the shop, once her brother Llewellyn's bedroom, and wanted the volume autographed.

They had recognised her as we came in. Not unusual, as she is her father's double; the same large, luminous eyes, the high forehead, the curly hair, the *retroussé* nose. In middle-age, instantly recognisable as Dylan's daughter, the features in

every detail identical to those of 'the cherubic boy' painted by Augustus John before she was born.

After the American ladies had departed, we went out onto the balcony and looked at the estuary, as Aeron talked about 'The Boathouse'. While she feels it is a very good thing that her father is not a forgotten genius, she has a certain understandable ambivalence to her childhood home being turned into a museum.

'When I visit now,' she said, 'I find it very upsetting to find all those strangers walking all over 'The Boathouse'. Sitting watching videos in the room where we lived and slept as children. Where we were happy, mostly, and sometimes sad. It shouldn't do, really, but it feels like an invasion of privacy, somehow. Most of them are day-trippers, on the package tour of South Wales and have never even read one of my father's poems or stories. They just come to see the place where they've been told this terrible, drunken writer lived. It seems like they're just prying.'

After coffee with Lorraine Scourfield, the long-time Curator at 'The Boathouse', we started our recording session out on the sunlit balcony, where Gilbert Bennett read Dylan's 'Should Lanterns Shine'. After that, Aeron reminisced about her childhood there; moved at times to tears as she remembered the games she played there with her brothers, clambering up and down the dangerous, slippery slopes on the cliffside. She remembered her father having his periodic bath in a big galvanised bath-tub, filled with buckets of hot water; and his childish foible of always placing 'dolly mixtures' all round the edge of the tub. He ate these as he bathed, and when

he had come full-circle and finished the last one, it was time to get out of the bath.

And she had a lovely memory of her father coming down one day from his wooden work-shed on the Cliff Walk with some draft pages of 'Do Not Go Gentle'. Her mother was busy preparing dinner, and when Dylan began to show his work to her she pushed him out of the kitchen with what she called his 'bloody poems'. Aeron laughed then at such arbitrary treatment of what afterwards was generally accepted as one of the finest villanelles in the English language, and one of the great poems of our time. So much for the prophet (or the genius) in his own country—or his own home!

Sitting on the sea-wall outside the house she recalled Christmas there and her father returning, somewhat inebriated, but with a huge doll for her. She remembered also, with great emotion, his return from various trips, to Swansea, London, and America, laden with children's books, and the wonderful way in which he read these to her. Indeed he didn't just read them; he acted them out; now playing the wicked wolf, now Red Riding Hood. 'He was a consummate actor,' she proudly boasted.

As children, she said, they very much resented the intrusion on their family life, their 'togetherness', by all sorts of visitors. Friends and acquaintances of Dylan's from London and New York, and students from all over the world, writing theses on Dylan Thomas, who came to interview him. There was one particular Scandinavian student, a very good-looking fellow, who took a shine to her mother, flirting with her. The child Aeron resented this and decided to do something drastic about it. So she collected all kinds of berries, some of them hopefully

poisonous, and made them into a special brew of what she called 'berry tea'. She then persuaded the young Lothario that *all* visitors to 'The Boathouse' were obliged to come down behind the woodshed and partake of tea with her and her collection of teddies and one girl friend. Reluctantly he agreed, after being told that 'my father expects it of you'. As he drank the berry tea she hoped he would keel over and die. He did not, but did get so violently ill afterwards that he had to leave next day. Served him right, she said with a smile, for flirting with my mother!

Then it was up the steep steps from the house and along the tree-lined walk to Dylan's wooden shed, where most of the great poems were written. The shed where she had looked through the keyhole to see her father writing. She was quite emotional as we looked in there; the same old posters and scraps of paper pinned to the walls and the old kitchen table on which he wrote his poems exactly as he had left it over a quarter of a century before. From there we did a grand-tour of all the places in town where the family lived, The Castle, 'Sea View', and the house where Dylan's father and mother spent their last years in retirement, 'The Pelican'. Aeron remembered as a child visiting her grandparents there, snuggling up beside 'Granny Thomas' in bed.

Then it was across the road to the ancient and pleasantly dilapidated 'Brown's Hotel', where Dylan and Caitlin had gone regularly to play cards in the evening. There is a framed photograph of them, playing cards with the owners, still hanging above 'their' table. We took several coffees in the lounge and talked about Dylan and Caitlin, and Aeron recorded some more memories of her childhood. Then it was time to

make our last call, the little graveyard on the hill above the road to Carmarthen, where Dylan is buried.

On the way there we passed the school-hall from which on Thursday November 5th 1953, BBC radio put out a live broadcast. It included Dylan's talk about the town, recorded specially before he left for America. Aeron said her mother had been in the hall that day when the telegram telling of Dylan's collapse in New York was delivered to her. He died four days later without regaining consciousness. Aeron, then aged ten and at boarding school in England, was brought news of her father's death by her mother's sister, Nicolette Devas.

'I realised then, after a little time had passed, that our days in Lugharne were over. My mother could not bear to return there without my father. We only went back a couple more times after that. I could feel, even at that early age, my mother's bewilderment and distress over my father's death, and will never blame her for wanting to live the following years away from Wales, in Rome and Sicily.'

Beyond the village hall, in a bend of the road that leads on to Carmarthen, is the beautiful lychgate to the churchyard where Dylan is buried. As Aeron and I left the road and begin to climb the path under the overhanging trees, the primeval silence was broken only by the droning of bees and a sun-drunk grasshopper lisping in the long grass. Above us, higher in the churchyard, we heard singing. As I looked up, the first thing that came into sharp focus was the unmistakable little white wooden cross marking her father's grave; it shone in the sun amid a forest of sombre granite and marble headstones. We stopped involuntarily, as there was something surreal, something dreamlike, about the whole scene. A group of

children were gathered round the poet's grave; sitting, kneeling, standing, yet all singing—in that uniquely magical way of which only the Welsh are capable—singing the Reverend Eli Jenkin's 'evening song' from *Under Milk Wood*. We continued slowly and came into full-earshot in mid-song:

> *For, whether we last the night or no,*
> *I'm sure is always touch-and-go.*
> *We are not wholly bad or good*
> *Who live our lives under Milk Wood.*

It happened that the boys and girls of Llansamlet Comprehensive School, Swansea, with their teacher, Mari Lloyd Phillips, on a day's outing, were paying a musical tribute to the dead poet. But perhaps the best tribute to Dylan is the poem written for him, by Aeron, on the twenty-fifth anniversary of his death, 'Homage To The Poet':

> *Now we can look back through time and see*
> *and view objectively your life, your works,*
> *the art with which you plied your words,*
> *your life a mere periphery to your quest*
> *to enter the Creative force,*
> *Death and Renewal.*

> *And we, your family, whether in kinship*
> *or as fans of your great art and craft*
> *see you with more love and charity than you*
> * gave yourself*
> *forever intent on your destructive end,*
> *'the only way for a poet', you always said.*

> *Oh vain romantic!*

And in your love for the love you gave so
* unsparingly,*
never sparing yourself
from plumbing the depths
to show us the treasure there,
we turn to God (if to God we are so inclined) or
at the very least to the creative energies in
* nature,*
His creative force enshrined,
and thank Him for you,
and for your kind.

We made our last recording at Dylan's grave; a simple grave, marked by a plain wooden cross, painted white. Aeron spoke sadly of how she had grown weary of all the books and articles and radio and TV programmes about her father. The ones that vicariously rake over and over the ashes of Dylan's personal life. His drinking, his infidelities—real or imagined—his rows with Caitlin. It was all so much third- and fourth-hand literary gossip now, she said. Supposition, conjecture, misrepresentation of stories that have gained legs in the telling and re-telling for over forty years. Like the regurgitated vomit of voyeurs.

Before we left the graveside Aeron commented on the wooden cross and the need to renew it every few years. Some years before she had thought of removing it, replacing it with a granite memorial, but the local Vicar, of all people, had objected very strongly. The simple white, wooden cross he said was more in keeping with the image of Dylan; and the tourists liked it. So expediency ruled and the wooden cross remained.

That night we walked down through the village to 'The Cors' for dinner. Under the trees the summer dusk was gathering, and we both felt that by some wonderful alchemy

Laugharne was undergoing a metamorphosis and becoming Milk Wood. The ghosts of blind Captain Cat, Polly Garter, No-Good Boyo and all the other idiosyncratic denizens of the sea-town were not far away; they were all round us in the gathering gloom.

After talking about many other things over dinner, we came back to Dylan; for it is virtually impossible to be in Laugharne and not have all talk come back to Dylan. Dylan *is* Laugharne, and Laugharne *is* Dylan. Aeron talked again about his grave; how ironic it was that he should be buried on 'the wrong side of the hill', so to speak.

'Oh, I know,' she said, 'it looks out over lovely bucolic fields and hills, but away from the sea. And he spent all of his life writing about the sea. He loved that old Welsh sea. Doesn't seem right, somehow.'

In 1994, her mother, Caitlin, with whom she had a tantalising and frustrating love-hate relationship for many years, died. Ironically, yet fittingly, after all Caitlin's wandering since Dylan's death, she came back to Laugharne to be buried in the same grave.

Since that last meeting at Laugharne I haven't seen Aeron. We have kept in touch in a desultory fashion, and when we have talked on the phone, or written each other, it has usually been to enquire about each other's health. She has suffered greatly and been hospitalised often, and for long periods, with a rare disease called milofibrosis, which causes her great pain and lack of energy. And I have had much trouble with heart disease. In the six months after that last visit to Laugharne I suffered seven heart attacks and had to have a transplant. So we have always been concerned for each other on that basis.

Yet when we talk she is also always anxious to know what I'm writing, and tells me what she is doing—lecturing, giving readings of her father's poems and her own. And she has begun writing poetry again; very different from the poetry of that first book. Recently Aeron sent me some of these new poems; one of them an epitaph for her mother, *Survivor*. This poem reminds me of the best of Pablo Neruda; its flawless structure, its honesty and total integrity.

Survivor

As your names are cut
into the headstone
your death reshapes me

You have become two words
engraved and silent
I have endless words to spend

to speak on your behalf
what you would have said,
dead.

At your funeral, alive
you spoke,
unkind words.

Yes, I said,
from my wealth of words
flowers are acceptable.

That's why
flowers deck the earth
ready to cover you.

No, you said
before you became
words on a stone cross.

You were never that
fond of flowers
preferred bare order

you always said,
wanted a foreign place.
But that's enough

of your wishes.
' ... the repeat
of the endless rain.'

You spoke
you are
stone names.

Reading that, I was reminded of what John Arlott, one of Dylan's first producers at BBC radio, and staunch friend and mentor, said about the poet. 'I knew Dylan well, and loved him. And when I heard he was dead, I wept, for I always felt Dylan had a touch of divinity.' That touch of divinity, it seems to me, has already been passed down to Dylan's daughter.

Before The Prize

Seamus Heaney

In the autumn of 1986, through a most unusual sequence of events, I met the poet Seamus Heaney. I was slowly recuperating after a sudden near-fatal heart attack, which necessitated quadruple bypass to save my life. My son, a Trinity student at the time, was engaged in some voluntary work with one of the city-centre organisations for the unemployed. Some of those to whom he had been giving talks on Anglo-Irish literature had shown an interest in writing. Most of them, he found, were avid radio listeners and knew my name from 'Sunday Miscellany' and the many documentaries I'd made. He suggested to me that they would really appreciate my going along one afternoon and giving them some advice on how to write for radio. He also suggested it would be good rehabilitation therapy for me.

I accepted for those reasons but also for another, more private motive. It would be an honest way of saying 'thanks' to God, or the Fates, or whatever benign agency had ordained my survival. So one humid September afternoon, I sat down with fourteen unemployed men and women to tell them something about how to write for radio.

It was to be a one-off session, but I was so touched by their positive reaction to what I said, by their almost naïve

enthusiasm, that I suggested we organise a writers' workshop, which I would conduct free-of-charge.

They were overjoyed at this suggestion and immediately set about organising a room in the Public Library of a North City suburb. I went there, every Tuesday afternoon, for seven weeks, and got them working on various writing projects. They were a very diverse group, with just two things in common. They were all unemployed and they all loved reading and wanted to write.

Our weekly sessions went well. It soon became apparent however that while they all wanted to write, they did not all have a talent for writing. For some the ambition far outweighed the ability to achieve anything worthwhile. However, three or four did progress and inside a month or two had sold short talks for radio, and another was developing, with the help of RTÉ, the script of a radio play, afterwards broadcast. All most gratifying, but even more wonderful was the fact that whatever success one of them achieved was celebrated by all the others. This communal joy at every individual success was all the more incredible when one considered some of the problems many of them had to overcome.

For instance, during the second session I gave them an exercise to work on at home: write an 800-word article on any subject of their choice. Only nine had put anything on paper by the next meeting. The ones who hadn't written anything were very evasive as to why they had not. When I spoke to each of them privately, I was saddened greatly to find that they quite genuinely didn't have the paper to write on. What I took so much for granted, the paper whereon to write, they could not afford.

Next day I contacted a major stationery manufacturer, spoke to their marketing manager, and told him the story. I explained that I was a willing mendicant on behalf of these people in looking for some complimentary paper supplies, as I was giving my own services free-of-charge. The response was magnificent and writing paper was delivered immediately for the use of those involved in the workshop, with regular back-up supplies for the duration of the course.

On the fifth week of our scheduled seven I complimented them all on doing so well. I suggested we try to get some well-known, Dublin based-writer to come and read to them during our final session in two weeks' time. As with the paper supplies, I offered to be their 'go-between'. Was there anyone in particular? Twelve of the fourteen without hesitation named Seamus Heaney. They loved his poetry. It would be a dream come true if we could get him. Did I know Seamus Heaney, they asked. I didn't, but I promised I would do my best to make contact with him. We would see.

That night I rang Seamus Heaney, introduced myself and told him the story of how it had all come about. To my utter surprise he agreed to meet me for a drink and talk over what we might arrange. We duly met in the Merrion Inn. I told him they would like him to read some of his poems for them, and maybe look at some of their work. I felt I had to explain that, while they all wrote poetry, it was not very strong. Their talents, I felt, were much better deployed in trying to write radio scripts or stories and articles for publication. Seamus was most affable and greatly taken with their enthusiasm. I will always remember what he said to me: 'If you, after open-heart surgery, have the generosity to give them of your time over

seven weeks, I can surely find an hour to come and talk to them.'

And so it came about that our future Nobel Laureate came, one sunny October afternoon, to a North City Public Library to give an hour to our little group—and stayed for two-and-a-half. Seamus was wonderful, warming to them instantly, and they to him. Their welcome put him totally at his ease. We started with tea and home-baking that had probably cost them a relatively large part of that week's housekeeping. Then he began by asking them how they would like to do this 'session'. Would he read some poems first?

So for over an hour, he read from his own poems. Some poems of his own choice, some requested by them, allowing that the particular poems were in the three volumes he had brought with him. I remember that *Station Island* had been published about two years before, and most of the group were familiar with the poems in it. The very first request was for a poem called 'The Railway Children'. As the poet's slow, deep voice rambled musically through it, I could see, watching the faces of my fourteen 'pupils', that they were ecstatic, hardly daring to actually believe they were being read to by Seamus Heaney.

He stopped after that, and after each successive poem, to discuss it with them. Told them of its beginnings; what it meant to him. Asked them what it meant to them. And, with every single poem, striking a cord with someone or other in his little audience. After 'The Railway Children' one middle-aged woman told him it reminded her so much of her childhood, playing along the railway embankment beyond Glasnevin, where the tracks went away into what was then still the

countryside. A middle-aged man then said it reminded him of his childhood in the Midlands. He had been born and reared in a little wayside railway station at Hill of Down, 'way out in the middle of the bog', where his father had been Station Master. That recounting of childhood memories moved Seamus greatly.

And when he read his poem, 'A Kite for Michael and Christopher', the listeners sat entranced, especially by the exhortation in the closing lines:

> *Before the kite plunges down into the wood*
> *and this line goes useless*
> *take in your two hands, boys, and feel*
> *the strumming, rooted. long-tailed pull of grief.*
> *You were born fit for it.*
> *Stand in here in front of me*
> *and take the strain.*

There was a long silence after that, broken by a young man who said with utter sincerity and conviction, 'God! If I could really write, that's the way I'd like to put it.' I was surprised by this show of emotion, as the same young man had, for the duration of the course, never spoken a word. It was as if this poem had triggered something in him, loosed something in him, given him a 'tongue'.

Seamus was delighted with this spontaneous outburst, telling us that was one example of what writing of any kind— poetry or prose—is all about; being so moved, so touched by a certain phrase, a certain statement, that you wished you'd written it yourself. At this point one of the ladies asked if he agreed with what she had recently read, that good writing was about taking your clothes off in public. Before he could

answer, our class jester interjected, 'Metaphorically speaking, Mr Heaney…!' This raised a laugh, but when the laughter had died away, the poet's answer was very serious.

He agreed that while that was by and large true, it was absolutely necessary to remember when writing about very personal, private things, to be very restrained, very subtle and tactful. One should never risk embarrassing one's reader or listener by becoming too personal. That was the real secret, walking the thin line between the two.

Someone then asked Seamus if he would read one of his Glanmore sonnets; 'the one about the shipping forecast'. He seemed enormously pleased to be asked for one of the Glanmore poems, and took several minutes explaining to us how the particular sequence came to be written, way back in the Seventies, when he and his wife had gone to live in Co Wicklow; 'to risk the life of a freelance writer', as he put it. From that time he remembered most the great feeling of 'being alone' and 'being committed'. Two very necessary 'conditions' for any writer, he said. Listening to the BBC Weather Forecast on the radio, late at night, ringed round by the Wicklow dark, he was inspired to write:

> *Dogger, Rockall, Malin, Irish Sea:*
> *Green, swift upsurges, North Atlantic flux,*
> *Conjured by that strong gale-warning voice*
> *Collapse into a sibilant penumbra …*

When he had finished reading that, there was a silence as deep as the Wicklow silence he remembered from those nights long ago. Then, one of the class, an ex-seaman, spoke. He said the poem reminded him of his years 'deep sea'; brought back memories of a hundred voyages, of a hundred landfalls, stirred

his blood again, made him want to be standing on a heaving deck again, pitching and rolling. All shyness momentarily lost, the old 'sea-dog' waxed lyrical for a while, then suddenly became self-conscious again and stopped.

Delighted, the poet took this as an example of how you got 'ideas' for poems. Here was a wonderful poem waiting to be written. He exhorted the old ex-seaman to work on it. I don't know if he ever did, for some months after our workshop ended I heard that he had died.

And so we came to the time when the poet said he would look at what writing they might care to show him. Though they had written mostly prose for me during the past six weeks, what they showed Seamus Heaney was largely poetry. He looked over the poems and then asked each one, in turn, to read for him, explaining to them that poetry is always better 'listened to' than just read off the page.

The poems were not great poetry; by and large they were sentimental, nostalgic and romantic, though some had odd lines that stood out and made the listener think. But there was no mistaking the absolute sincerity with which their authors read them. And there was no mistaking the sincere and caring way in which the poet commented on each one.

He made little notes as each reader performed, and afterwards enumerated, firstly, all the positive aspects he found in each poem. Secondly, he was constructively critical in the most gentle way; but never, ever, even remotely patronising. Above all he exhorted them to read as much poetry as they possibly could, and not to be afraid to 'imitate', to 'copy' writers they admired. After all, he explained, if they were

aspirant painters in art school, they would spend a large part of their time copying old masters.

When someone asked about 'entering their writing for competitions', he was magnificent in his answer. They should not think in terms of being 'in competition' with anyone, not even with each other. He felt that each person who had the urge to write or paint was unique, and that one poem could not really be compared with another. Each poem stood on its own. He ended by telling them what a 'lonely business' writing was. The only real reward being when something you'd written touched and moved people. And he thanked them for giving him that great pleasure—being moved by what he had read to them, as he in turn had been greatly moved by what they had read to him.

I never met Seamus Heaney after that. I read him regularly, have bought all his books, and rejoiced in his winning the Nobel Prize. But more than anything else, I remember the unique nimbus of tranquillity he carries with him. I don't think I have ever been in the presence of a man with such an air of imperturbable creativity; a man whose face radiated such a benign knowingness of those tremendous trifles that really matter in life.

The Journey Inward

Henry Miller

In the fall of 1969 as one of a series for NBC in New York City, I gave a radio talk on Thomas Merton, the Cistercian monk and writer, who had died the previous year. In the week after the broadcast I got the usual phone calls from listeners who had liked what they'd heard. The names meant nothing; I knew none of them. They were just people magnanimous enough to take the trouble to contact me. But among those calls was one from a man who introduced himself as Henry Miller. *That* name rang many bells.

While I was still in a state of surprise that Henry Miller would bother to ring me, he went on to tell me how much he had enjoyed my talk, and asked if there would be more. He would like, he explained, to meet somebody who had met Merton. The monk and he had exchanged several letters in the early and mid-Sixties, but had never met. He had intended travelling to Kentucky to visit Merton, but something always got in the way.

'Yas, yas!' he laughed, his 'yes' sounding like a little explosion of gas. 'Mostly old age!'

Miller was seventy-eight at the time of the phone call and had been living in California for many years. He was paying a brief visit to New York to consult with an eminent eye

specialist about his failing eyesight; and to make one last visit to a Brooklyn he remembered from his boyhood but which, he lamented, didn't really exist anymore.

'You know, Tom Merton and I had a great correspondence for a few years. He liked what I wrote and I liked what he wrote. Not in a "mutual admiration society" kind of way, though. Your radio piece made me feel you knew him pretty well. Would there be any chance of meeting for a little while, before I go back to the West Coast?' The old man's voice sounded much younger than his years, mellow and resonant, with a faint touch of apology for asking. It was difficult to relate it to the image of Miller that most of us had carried with us for so many years; the vagabond, the outrageous extrovert, the nomad, the outspoken enemy of cant; the writer whose books had been banned and burned in public for their overt sex, their scatological predilections.

'Sure,' I said, not even attempting to conceal my eagerness, 'whenever suits you.'

'Well, I'm booked to fly back to California, Friday. Got three more days. How about tomorrow? Yas?'

We met next afternoon in The Village, at a little wine bar he nominated; it was, he explained, a place he had known in most of its many incarnations over the years. Yet as I looked at it then for the first time, it was hard to imagine it as anything other than the chic place it appeared to be. Hard to visualise it in the many manifestations he described to me as we waited for our claret to arrive.

'You know, used to come here way back, when it was just a coffee shop. Anaïs (Nin) was in town then, and a lot of the old

bunch. And later, when I came back from Paris, it was a Mexican restaurant for a while.'

He went on to bemoan the fact that he could never help himself when it came to being drawn back to places he had known in his past. He felt there were all these invisible umbilical cords still connecting him with places that, in actual fact, didn't exist anymore.

'You know, all those streets of early sorrows, and streets of early joys too!' he said. 'Glimpses of the moon and glimpses of hell! Yas, yas!'

Our wine arrived then, a bottle of a very good claret. The Latin-American waiter, stiff, formal, aloof, stood before us with the bottle held against the length of his outstretched arm for Henry's inspection. With a mischievous glint in his still twinkling eyes, the old writer winked at me, then reached out as if he were being invited to inspect the label. The waiter was disconcerted.

'It is the correct wine, *Señor*? No!'

'Yas, yas,' the old man drawled laconically. 'Just admiring the lovely piece of printing on that label! Real high quality! My compliments to the printer.' And then he proceeded to taste his wine.

'But the wine? Is the wine to the *Señor*'s liking?'

'Not sure yet. But if it isn't we'll let you know. But that printing! Wow! That printing is something else!'

'But you will let me know. Yes?'

'Yas! If it's not right you can take it back. Give it to the cat!'

'The cat, *Señor*?'

'Sure! Every place like this should have a cat. An alcoholic cat. Feed it the returns, the left-overs.'

'Yes, *Señor*.' Totally disconcerted now, the waiter withdrew. We drank our wine in silence for a few minutes and watched him talking with the manager at the far side of the bar, no doubt telling him of the crazy customer at the window table, and pressing for the instant acquisition of an alcoholic cat.

'Bastard,' Henry laughed. 'Hate that kind of crap. Dancing round like that. People like that need to be sent up or put down.'

I could only laugh with him, gratified to find that unlike many, the old writer had not changed with time, had not, as often happens with erstwhile rebels, 'mellowed with the years'. Here he was still a rebel at seventy-eight, as outlandishly mischievous as the young man of *Tropic of Cancer, Tropic of Capricorn* and *The Rosy Crucifixion*. He was still, as his friend Lawrence Durrell once referred to him, 'the rogue elephant of American literature'. He respected nothing and he respected everything. His work and his life went far past the parameters of what conservative, hidebound people found acceptable. He wrote about everything under the sun and the moon; he wrote about Greek landscape, ancient gods, reading, women, making love, food, drink, modern life, hell on earth, heaven on earth. Much of what he wrote was veridical, prophetic; for ultimately Henry was always 'on the side of the angels'.

'You know,' he said, 'that's one of the things Tom Merton was always on about in his letters. The crap that surrounds us, in so many manifestations. He once said to me in a letter that we spend our lives battling with mountains of crap. And how right he was!'

'That doesn't surprise me,' I said, remembering how impatient Father Louis would become with what he considered small talk. 'He was a man who didn't suffer fools gladly. Even amongst his fellow-monks.'

'Yas, yas, that adds up. You know, I remember once he wrote to me—I think he was in charge of the novices at the time—saying one of his prime functions was to save the young monks from getting buried in ideological manure. But he did go on to say that he thought that monastic manure was not nearly as obnoxious as the manure being forked about so indiscriminately on the outside. Jesus! What a wonderful way for a monk to talk! What a guy! Yas, yas!'

'He certainly was. What a pity you two never got together.'

'Well, you know, that was my fault. But almost everything seemed to be against it from the start. Geographically we were a long way from each other. And you know, I was having a lot of—well—domestic problems—about the time we were corresponding. And a lot of health problems. The kind that come with age. And of course, he was a monk and confined to his monastery, so I would have to go to him. So sadly it never happened. We only had this exchange of letters for a few years.'

'How did it start, how did you first make contact with each other?'

'Oh, sometime in the spring of 1962. I had just finished reading his *Wisdom of the Desert* and *Original Time Bomb* and felt I must write and tell this wonderful man how moved and stimulated I was by the things he was writing. And you know, he wrote me a very prompt reply, saying he had often thought of writing to me, but never had because he thought I would be

too busy and have too little precious time to myself. Imagine, this great man, this great writer, who was so busy himself, even stopping to think like that! Yas, yas! Anyway that's where it began. I remember in that first letter he told me how much he loved *Big Sur and the Oranges of Hieronymus Bosch*, and how he considered *The Colossus of Maroussi* to be, and I quote now, "a tremendous and important book". And you know, in that very first letter, I became aware of his wonderful sense of humour.'

'Oh, yes,' I agreed, 'he did have a great sense of humour. Said to me once that a sense of humour was no good anymore, we needed to cultivate a sense of the ridiculous to cope with the kind of rubbish we had to encounter.'

'Yas! The manure, the crap, the shit! It's all round us, you know.'

We were sipping away at our wine, nearly half-way down the bottle already. I could not help, as I looked at the elderly Miller across the table, thinking of the famous phrase he had made his own over fifty years before ... 'Always merry and bright!' Through all the many vicissitudes of his life—in New York, in Paris, in Greece—that phrase had epitomised his attitude. For he was *the* great naïf. As indeed was Merton. The writer-monk and the writer-vagabond must have instantly recognised each other as being fellow-travellers, pilgrims on the same pilgrimage; that wonderful journey Miller once described as '... the journey inward toward the self'. The journey that, for Merton began in solitude and ended in solitude—'... the abyss opening up in the centre of your own soul'. Connections! Connections!

'Say, you know, you're the one to tell me this, Bill,' the quiet, resonant voice interrupted my reverie. 'Do you think Merton and I look like each other?'

I was surprised by his question, and must have shown it, for he went on to explain. 'You know, he sent me some photographs once and I wrote back and said something about the resemblance, mostly between our faces. And I also mentioned that he reminded me of Genet. He seemed tickled by this, you know, and in his next letter said he was glad I thought so and he liked the association with an ex-con.'

Here the old man stopped short, his voice choked by emotion. He looked at me in silence for a few seconds, eyes swimming with tears.

'And then,' he continued, the voice steady again, 'dammit if he didn't say something I could well have said myself. You know, he said it seemed to him that the only justification for a man's existence in this world of chaos was for him to be either a convict, a victim of plague, or a leper.'

Looking hard at Miller then, I could see how like Merton he was. The same balding head, the same shaped face. But the biggest resemblance was the great sense of vitality and energy they both gave off. You could sense the 'charge' in them; a coiled-up spring; a time-bomb waiting to explode. And there was the same impatience with what they both perceived as crap, manure, shit.

I told Henry this. Told him I thought he and Merton both had what Hemingway considered to be one of the greatest gifts a man, especially a writer, could have, the greatest birthright; the gift of being born with a built-in shit-detector.

'Yas, yas!' he laughed heartily. 'And you know, how true, how very true!'

I also told him the resemblance was not just a visual thing, it was more than that. What I said seemed to please him, though he just nodded and smiled. But there was something else I did not mention. I did not mention that he had this same nervous way of repeating certain words during a conversation as Father Louis did. Not the same words, of course. With Father Louis it was the staccato interjection—'see, see'; while with Henry it was 'you know' and 'yas, yas'.

Looking at him sitting there, smiling benignly, the accumulated wisdom of all the years seeming to wrap him round like a great cloak, invisible yet contradictorily tactile, I thought how like a monk he looked in his old age.

'You'd have made a great monk,' I said, 'you really would.'

'What d'you mean *would've*,' the eyes flashed mischief again behind the thick lens, 'I reckon I've been a monk all my life, you know. Well, a kind of *lay* monk. I've had it all—the poverty, the meditation, the work, the prayer, the total dedication. But I know, I know, the women in my life would have disqualified me from a monastery.'

We agreed on that and laughed. And he went on to talk about some books he'd been reading about ancient European monasticism. About Bernard of Clairvaux and the kind of chaos he inherited when he first entered the monastery. He chuckled to himself as he recounted some of the stories of the lay-brothers sent out in groups of six or seven to work outlying farms bequeathed to the monasteries by wealthy patrons. I could see he relished the idea of these brothers, smarting from the draconian rule under which they had lived for years in the

close confines of the monastery, suddenly enjoying the freedom of living outside from Monday to Saturday, and returning to their monasteries only on Sundays.

'You know, they had a ball, these poor guys. Went into the nearest town every night and got drunk and screwed around with the local women. Only when all the pregnancies came home to roost did the various abbots get to know! Poor old Bernard's first job, you know, as abbot, was to clean up that kind of mess! Yas, yas!'

In reply to this I told him I thought he'd been doing his homework on the Cistercians. He agreed that he had, and he found it all fascinating; a very different world from any of the many worlds he'd lived in. He thought it marvellous that monks had been so human, so recalcitrant, all those centuries ago.

'You know, Tom Merton paid me the greatest compliment I've ever had. I'd sounded off in a letter to him about Europe and Zen and Thoreau. In his reply he said he resounded to everything I'd said, and referred to my basic Christian spirit which, he said, he wished a few more Christians shared. That stayed with me. Jesus! I was only sympathising with the poor bastards getting away from under the thumb of the abbot for a few days every week. Not working their balls off back at the monastery. You know, Bill, I never thought of myself in those terms, being 'Christian', being anything in particular—except just plain human.'

I then told him of how very, very human a person I had found Father Louis to be, and when I had finished the old writer sighed and told me of the monk's reaction to reading Alfred Perles book—*My Friend, Henry Miller: An Intimate*

Biography. Henry said he could hardly believe it when Merton wrote to tell him certain parts of what he had just read sounded very familiar; the kind of life he himself had, to a certain extent, lived before he joined the Cistercians at Gethsemani. And the part he hadn't lived, he wished he had!

We had come to end of our bottle of claret now. The obsequious waiter hovered close, uncertain as to whether he should approach us or not. It was coming time to go. Henry's mentioning Europe reminded me of something.

'Speaking of Europe. Did Father Louis ever mention Saint Michel-de-Cuxa to you in his letters?'

'No. Where is it?'

'A centuries-old French monastic foundation in the Pyrennes. Near where he was born. But the cloister of that monastery has been transplanted and now stands here in New York ...'

I went on to briefly tell Henry the story of The Cloisters. He was, to quote himself, 'flabbergasted'. So interested was he that I offered to take him next day uptown to where the old monastic stones had been reassembled near the Palisades.

The sky was clear and the autumn sun warm that morning. Henry couldn't walk for long, so we sat in the sunshine and alternated between talking and long silences, when we let the wonderful atmosphere of the place wash over us, like some undeserved blessing. I told him the full story of the place, as Father Louis had told it to me at Gethsemani. Told him of all the times I had come here since; of how it had become a sort of Mecca for me; a place of escape. Moved, the old man got up and shuffled across the gravel path to touch the old stone, stained and abraded by the weather of centuries.

'Yas, yas! Your bolt-hole!' he said. 'Everyone needs a bolt-hole. And Tom used to come here when he was at Columbia?'

'Yes, often.'

'Sure does have that "charge" you talked about.'

He shuffled back to where he'd been sitting and slumped in the sun again. It was a long while before he broke the silence.

'Say, Bill, is a Cistercian monastery anything like this? The atmosphere?'

'Yes. Very much like this. But then, this *is* a Cistercian monastery.'

'You know, you can feel it all round you.'

'There were many times, this past year, when I came here around dusk, and could sense the spirits of all those old French monks around me in the half-light.'

'Yas, yas! Maybe I should've been a monk after all. Especially back in old Bernard's time. But a *lay* brother. You know, I fancy that idea of working one of those outlying farms and going into town at night and raising some dust! Though I can't see the boys down in Gethsemani romping round the Kentucky hills. Say, do you believe in reincarnation?'

'Don't know, never really thought about it.'

'Well, there's this guy back on the Coast. Often comes to see me at Pacific Palisades. He's into all sorts of things, like reincarnation. Says if you live a good life first-time round, you can have a choice of who you want to be second time round! You know, Bill, I've been thinking. Maybe I can arrange to be a Cistercian monk next time round! Yas?'

'That would be great,' I joked. 'You and Father Louis could get together and collaborate. Just imagine the books you could write together!'

'Hold it! Hold it! That's not so funny as you think! I remember he wrote me a letter saying he liked *Stand Still Like the Hummingbird* more with each reading. Said he felt I made it all seem as obvious as if he had written it himself, only I had said it better than he ever could. Took it as a great compliment when I told him he was like the Transcendentalists, and said he would try to be worthy of that. Jesus, Bill! What modesty from a man like Tom Merton!'

'You know what Dan Berrigan said of him?' I replied, lost for words now. 'That he was a man "crazed with caring about the human condition..." And he was.'

'Yas, yas, of course he was. Told me that writers like us were, to a great extent, voices crying in the desert. And you know, he made the extraordinary statement that he thought his best books were the ones nobody was reading! But he went on to say that we were here—*he* in his monastery, *me* in California—for a reason. Pretty much the same reason in both cases, he said. We were here to "live" and to "be", and to help others with the recharging of their batteries.'

It was time to go then. Henry had an appointment to meet an old friend from his early Brooklyn days, so I dropped him off near Central Park where his friend was waiting. The friend's son was going to drive the two old men around a Brooklyn Henry said was not there anymore. Even the street he had made famous in his books, 'The Street of Early Sorrows', was not recognisable anymore.

'It's all crap now,' he said seriously. Then, laughing heartily, he added, 'Well it was crap then too, you know, when I was a boy! But a higher grade of crap. There are grades and grades. Yas, yas?'

There was no answer to that. I held his outstretched hand. It was warm and firm and full of the energy that emanated from him, that surrounded him like a halo.

'But' he said as we parted at the kerbside, 'you keep it all up here and in here,' and he touched his head and his heart, continuing, 'then nobody can *really* take it away. Yas!'

I spent the rest of that afternoon back at my desk in a high-rise office block on Fifth Avenue. I was working on a 'story-board' for the launch of twenty-three new shades of lipstick and nail enamel for the following summer. The names—Love Me Pink, Forget-Me-Not, Luscious Red, Sex Fire, Coral Reef were pinned to a wall-chart in front of me. But some of Miller's mischievousness had taken hold of me, and instead of those names I found myself intoning a somewhat more profane litany ... 'Crap Pink', 'Manure Red', 'Shit Purple'. All around me, in their own glass-partitioned, state-of-the-art offices, others laboured at their equally ludicrous tasks. I thought of what Paddy Kavanagh had once said, when as a prematurely inebriated paid after-lunch speaker at the launch of a new range of shampoos, he lost the run of himself. Overcome with self-loathing at what he was allowing himself to do for a few pounds, he abandoned his prepared speech to tell his paymasters and the assembled media people, 'Yerrah, you should all be ashamed of yourselves, sitting here doing this, when there are decent men footing turf on the bogs of Monaghan!'

My thoughts however were still very much with Henry Miller. I visualised him out there in the mellow fall sunshine, searching for a Brooklyn that no longer existed—except in his mind. Going slowly to the window, I stood looking out at the chiaroscuro of the sprawling city. Standing there, I remembered Henry's inward journey from *The Colossus of Maroussi*—'voyages are accomplished inwardly, and the most hazardous ones, needless to say, are made without moving from the spot'. And I thought of Merton's 'country of standing still', whose centre was everywhere, its circumference nowhere. Very much brothers in their thinking and writing; the maverick and the monk, both on the side of the angels.

The Little Mornings

Mick Mulgrew

In all my travels round this tortured old planet I could be sure
of one thing. Wherever I went—from Blacksod Bay to Belize;
from Rosslare to Rangoon; from Kanturk to Kentucky—there
was always an Irish man, or woman, there before me. I found
them in the obvious, the expected places to which the Irish
have for centuries gravitated—like London, New York,
Boston, and the mission fields of Central America; in the
traditional, conventional roles— navvies, clerks, nurses,
doctors, nuns and priests.

But I also found them in the most unlikely out-of-the-way
places, fulfilling themselves in the most unconventional
pursuits; a Corkman managing a brothel in New Orleans; a
Donegal ex-nun working as a 'white hunter' in Africa; a
chocolate-skinned Belizian, born of Creole mother and Irish
father, who gloried in the name of Esteban O'Leary, running
his own 'swine farm' near the Guatemalan border. However,
the most unique enterprise I've ever come across was in
Mexico, involving an Irishman from Co Mayo, from that
lovely, wild bog-land beyond Bangor Erris.

As many a fine adventure does, this one began with a night
on the town—the town, in this case, being Mexico City where I
was temporarily domiciled in 1963. I had only been there a

week, but the altitude, the lethal cocktails, the Mexican food and the after-dinner drinks, had already begun to feel something akin to an out-of-body, and out-of-mind experience. I needed renovation, and quickly. One of the group of revellers, Richard, who hailed from Cahirciveen and now worked as an attorney in Mexcio City, was an old Mexico-hand and knew exactly where to go for such therapy.

We hailed a taxi and Richard shouted some obviously magic words to the driver.

'*A Las Mañanitas, por favor! Pronto! Pronto!*'

'*Ah, Las Mañanitas! Si, si, Señor!*'

As we proceeded at high speed over the winding mountain road, the pale morning sky behind the dark blue bulk of the Sierra Madre ahead of us was being slowly suffused by a crimson sunrise. As if some invisible hand were slowly spilling coloured ink all over a sheet of blotting paper. Then, when it seemed the sky could absorb no more of this molten colour, the mountains began to change from indigo to paler blue and the distant peaks loomed nearer in the new light. You could sense the as-yet-invisible sun edging up closer to the horizon. The narrow road had levelled now after our climb out of the city. We were driving on a plateau on top of the world. We passed three coaches and several cars. In my inebriated state I thought I might be hallucinating. I was not.

'Ah, *Señor*!' our madcap driver shouted, 'there are many for *La Panacea* today. *El Medico Miguel* will be busy! *El Dispensario* will be crowding!'

My God, I thought, I am in worse condition than I imagined; they are taking me to a doctor. I looked to Richard for explanation.

'Worry not!' he shouted over the noise of the trundling car, 'we'll soon be there and I'll explain all.'

Then, for the first time since we left the city, the taxi slowed; the road dropped downhill. We rounded a bend and there, set into the side of the overhanging plateau, facing east, was a large roadhouse, with a balcony running the full-length across it. Two coaches and some cars were parked in front. The large sign above the door was, to say the least, colourful; the lettering embellished with serif and double-serif, dot, dash and curlicue. A perfect example of circus art. It bore the legend: *LAS MAÑANITAS—Candega y Dispensario de Miguel.*

The whole scene, especially the dawn drinkers already seated on the balcony, reassured me. I was not being taken to a clinic; men in white coats would not appear. But as we stepped from the car a man in a white shirt *did* appear; a splendid athletic fellow, about six-foot-three, slim, bronzed, with long, blond hair tied in a ponytail; every inch a Viking. Richard and he greeted each other with a hug. We were then all introduced to the blond giant, owner of *Las Mañanitas.* Surprisingly, his name was Mick Mulgrew, known to all his Mexican friends as Miguel. With a soft, unmistakably West of Ireland accent he urged us to hurry to the terrace, to make sure of a seat before the sun came up. He would join us later.

We found a table on the terrace and ordered some strong, black coffee. Richard explained to the waiter that we needed *La Panacea* for me. My friends sipped their coffee and I drank *La Panacea*, a small draught of thick, blue-black, tasteless liquid that slipped like some benign, healing balm onto the troubled waters of my stomach. The coaches and cars we had passed along the mountain road had arrived now, and the

newly arrived guests crowded balcony and car park to watch the sun come up behind the Sierra Madre.

At first the great crimson disc edged up over the mountain rim in a series of little jerks, then levelled out into a smooth slide, as if being steadied by some invisible hand. Once clear of the mountain, the golden morning light flooded the whole vast, arid landscape. Flashing on the windows of *Las Mañanitas*, and on the windows of the few villas across the plateau behind us, it was as if signals were being sent in Morse across the morning mountains to welcome the new day.

La Panacea did its work of renovation in record time, and soon I was sipping black coffee and feeling half-way normal again. I was anxious to know something about the place and its Irish owner before he joined us. So Richard, who had been part of the large Irish community in Mexico City for the past eight years, and who knew 'Miguel' well, filled me in as he had earlier promised.

Mick Mulgrew had left Mayo over twenty years ago, as a boy of seventeen. He had gone first to Boston, but after a family squabble with his brother there, he had worked his passage as a deckhand on a coaster to British Columbia. Here he had managed to get himself a post as a lighthouse keeper at Discovery Island five miles south of Victoria. However, the nomadic streak in Mick soon had him moving again; to Central America, where he worked for several years in the logging camps of what was then British Honduras. In a brawl over a Creole woman, he had killed a Nicaraguan worker at the logging camp. This tragedy was followed by instant flight across the border to Guatemala, and two years of lying low, before making his way to Mexico City.

Here he played poker for a living, having become proficient at it while working in the logging camps. One night in a poker game in Mexico City, he won the deeds to a ramshackle *cantina* out in the hills, from its Mexican owner. It had been used for various purposes until then; a *bodega* of sorts, a *cantina* of sorts—open one day, closed the next, depending on the owner's luck at poker. Mick went a few days later to inspect his 'winnings', and having no fixed abode just then, he shacked up there for the night. Waking early next morning, he had witnessed the 'miracle' of the Sierra Madre sunrise. Instantly his mind was made up. This at last was home; he would settle here, renovate the old place, make it a proper spot for tourists to visit. And he would 'sell' the sunrise. Looking at his first sunrise, he knew what he would call the place ... 'The Little Mornings'—'*Las Mañanitas*'.

So *Las Mañanitas* was born. With a typical whimsical flourish Mick had subtitled it *Miguel's Candega;* coining the latter word from *cantina* and *bodega*. The place flourished. Miguel, as he was thereafter known, was popular; and he surprised even himself with his business acumen and a flair for promoting his establishment. Busloads of tourists soon flocked to see the sunrise there and eat breakfast on its terrace. And within a few months of opening, Miguel had created his speciality—*La Panacea*.

With incredible perspicacity he had quickly gauged the great number of early-morning visitors who arrived badly hung-over after the night's carousing; some tourists, some business people. Every morning he had dozens of requests for 'something to settle the stomach', 'something to clear the head'. And so he had introduced *La Panacea*, the concoction I had just sampled, and added *dispensario* to the fascia board.

His Mexican staff immediately began referring to him as *El Medico Miguel,* and so the legend of *La Panacea* was born, which increased his turnover incredibly.

'But *La Panacea,*' I said to Richard when he had finished. 'What's in it? It certainly works!'

He was about to answer when Miguel came and sat with us, apologising for being away for so long.

With a quick glance at the empty glass among the coffee cups, he asked, 'Who needed the cure?'

'I did.'

'It works!'

'It certainly does. What's in it?'

'Ah, that has to be a secret,' the blond giant said quite seriously. 'But I can tell you, it's an old Irish recipe. I got it from my grandfather in Mayo. They were using it there before I was born.'

Looking at him, I thought I detected the slightest suggestion of a mischievous smile on his face, and just the minutest fraction of a tongue-in-cheek. But I couldn't be sure.

'What part of Ireland are you from, Bill?' he asked.

'The South—Waterford. Richard tells me you're from Mayo.'

'Yes, between Crossmolina and Bangor Erris. Do you know that country at all?'

'I do. Quite well. I went over there some years ago, to do a bit of research for a magazine article I was writing about a man called T.H. White.'

'Tim White, the writer?' he said, astounded.

'Yes, he lived in that area for a while.'

'I know! My uncle, my mother's brother, used to be his ghillie. Many's the day I spent with them as a boy, shooting on the bog or fishing the Owenmore River.'

For the next hour Mick Mulgrew and I talked animatedly about that lovely country between Nephin and sea. Richard said later that he had never seen him so positively excited about anything. Among other things Mick told me of a particular night, shortly before he left Mayo for ever, when he and his uncle, after a day's shooting on the bog, had sat in White's kitchen at Sheskin Lodge, and listened to Radio Eireann. To the result of a poetry competition, in which a poem of White's won first prize. I could see Mick was deeply moved by the memories flooding in, as he tried to remember some lines from that poem. I knew the poem myself, but felt I should not spoil it for him by prompting him.

'I have it!' he said, a look of triumph on his face, 'it was a poem about Sheskin. I remember he wrote it out for my uncle after the broadcast. God, he was so proud of it! I can't remember the opening, but some lines are coming back to me . Then, haltingly, in a half-whisper, seated among all those tourists and bathed in the glory of that Mexican sunrise, he spoke the half-remembered lines that so well described the Mayo moorland where he had grown up:

> ... *the dragon blood of the fuschias in forests,*
> *and primroses*
> *And peas in September. All this in twenty miles*
> *of bog.*
> ... *the red salmon, who would not take,*
> *Even with all our prayers, leaping, leaping out*
> *of the Owenmore* ...

All three of us were quiet for what seemed a long time after he had finished. I broke silence then by telling them of my brief meeting with White, in 1944, when I was a boy of twelve.

'I had left Mayo by then,' Mick said. 'Was a light keeper in British Columbia. God, you never know, do you! After all those years meeting you, and the connection with Tim White.'

We had to leave shortly after that. There was a day's work to be done; a day's potatoe peeling in as much as Mexico was, for me, no different from New York. I did not see Mick Mulgrew again until Christmas. Then, two weeks before the holiday, I got a card from him, inviting me to his Christmas-morning Irish Breakfast. He had also scrawled a message across the bottom of the card, asking if by any chance I could get the words of White's poem about Sheskin. When I asked my friend Richard about this 'breakfast', I was told I must not miss the occasion. He would tell me no more: it would spoil the surprise. So together with over 100 of the Irish community in Mexico City I went out to *Las Mañanitas* at 10 o'clock on Christmas morning.

In the few years since Mick had taken over the establishment, this Christmas breakfast, strictly for the Irish, had become a tradition. Through channels known only to himself, employing gentle threat and well-meant promise, plus a discreet greasing of certain palms in various airlines, Mick managed to have copious quantities of Denny's sausages, rashers, black and white pudding, and free-range Irish eggs flown out from Ireland on Christmas Eve. And so a full Irish or —as Mick referred to it— a 'full-frontal' breakfast was served to all guests on Christmas morning, compliments of the house. Irish songs were sung, Irish stories told, and for a couple of

wonderful hours a rocky Mexican hillside became a little bit of Ireland.

Mid-way through that particular Christmas session, Mick announced that a friend of his, 'fresh out of Ireland', was going to give us a poem about the place where Mick himself had been born and reared. I duly obliged with White's lovely lines, beginning with:

> *I was alone for dinner, with one candle,*
> *Reading a book propped against it (about the*
> *stars).*
> *There was a grouse and wine and outside the*
> *French window*
> *Nephin waited for Mars.*

When I finished there was silence. As I looked around, my little audience of well-heeled expatriates looked stunned, as if they had been hypnotised; each lost in his or her own 'Sheskin'; for wherever you happened to come from in Ireland, from Donegal to Kerry, there were references in White's lines that evoked memories of home. When the applause had ebbed, Mick addressed his guests. 'Isn't it wonderful to be here on this Mexican hillside, on this Christmas morning, all of us Irish, listening to a poem written by an Englishman about the old country, and read by an Irishman who as a boy of twelve had seen the author in a Dublin pub!'

That was the last time I saw Mick Mulgrew. Early in the New Year I went back to New York City. Through my friend Richard I kept in touch with Mexico. In one of his letters a year later, he wrote that Mick had fallen in love with a wealthy American widow who had come out to *Las Mañanitas* one morning for *La Panacea*. She lived across the Gulf, on the

coast at Cape Sable, between New Orleans and Houston. Subsequent letters referred to Mick spending more time at Cape Sable than he did in Mexcio; there were, Richard said, rumours of a wedding.

Eventually, sometime soon after I had left New York and returned to Ireland I got word that Mick had sold *Las Mañanitas*, married his wealthy widow, and gone to live in Cape Sable, where he re-named his wife's house 'Sheskin' after Sheskin Lodge. Richard, who had been his attorney for many years, continued to handle his legal affairs, visiting him regularly there, and keeping me up-to-date. Mick enjoyed a very happy marriage; he played golf, sailed his yacht, did the party circuit with his new wife; became a sophisticate. But for a man who had led the kind of life he had led, all that was perhaps not enough. For I remember Richard saying in one of his letters, after a visit to 'Sheskin', that Mick resembled some fine wild animal taken into luxurious captivity, yet itching to be free again. He constantly talked of Mexico and of how much he missed it.

Mick Mulgrew, a.k.a. Miguel, died at Cape Sable in 1974, aged fifty-two, after a two-year battle with cancer. He remained eccentric and idiosyncratic to the end. In his will he made provision for his own funeral, with very explicit instructions as to how it was to be conducted. His body was cremated and on a day when the wind was blowing from the northeast, his ashes were scattered from the cliff-top near Cape Sable. Hopefully that way they blew clear across the Gulf and with good luck, some smidgen of his remains came to rest on the arid Mexican hills near his beloved *Las Mañanitas*.